IMAGES
of America

OXFORD

This map of Oxford was created from a survey by J.M. Kennedy and W.J. Mollyneaux in the early 1850s. It shows the Public Square in the center of the business district at the intersection of High and Main Streets. Because this area was the highest elevation in the Village, people in Oxford have always gone uptown instead of downtown to shop. Miami University is located on the University Square just southeast of Uptown. The university's Student Burial Ground can be seen in the northeast corner of the mile square village, and the public Burial Ground is denoted on the south side of Spring Street. To use this map to find locations mentioned in the book, readers should note that street names have changed. Current names are used in the book, so Exterior South, Exterior West, Exterior North, and Exterior East Streets are now called Chestnut, Locust, Sycamore, and Patterson, respectively. South Street is now Collins, West Street is now College, North Street is now Withrow, East Street is now Campus, College is now University, and Wood is now Tallawanda.

IMAGES
of America

OXFORD

Valerie Edwards Elliott

ARCADIA

Published by Arcadia Publishing
Charleston SC, Chicago IL, Portsmouth NH, San Francisco CA

Printed in Great Britain

Library of Congress Catalog Card Number: 2004100697

For all general information contact Arcadia Publishing at:
Telephone 843-853-2070
Fax 843-853-0044
E-mail sales@arcadiapublishing.com
For customer service and orders:
Toll-Free 1-888-313-2665

Visit us on the internet at http://www.arcadiapublishing.com

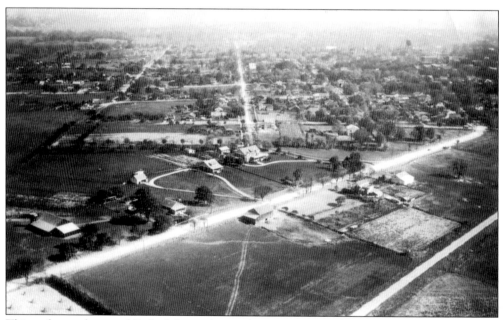

This early aerial view of Oxford shows the northwestern part of the Village in the late 1920s or early 1930s. The picture, taken from the west, shows the railroad at the lower right, College Corner Pike in the foreground with farm fields on either side, and the Uptown Water Tower at the top right.

(*cover image*) One of Oxford's most prolific photographers, Frank R. Snyder, captured this image of a group of students sledding on South Campus Avenue in 1922.

CONTENTS

ACKNOWLEDGMENTS

It is probably impossible to thank everyone who contributed to this book because many of the pictures in the Smith Library of Regional History were taken by photographers whose names are not known. We are indebted to them for the earliest images of Oxford that were taken in the nineteenth century. Photographs taken more recently were donated by the families of the photographers, and to them we are most grateful. The works of Frank R. Snyder (1875–1958) were made available by his son Frank K. Snyder; the photographs by Gilson Wright (1905–1998) were donated by his daughter Barbara Wright Reed; and the pictures by George R. Hoxie (1907–1984) were given by his widow and children.

To others who helped with this project, I offer my sincere appreciation. Dr. Robert Schmidt, Miami University archivist, answered many questions about the history of Miami University. Diane Kaufman of the Western College Memorial Archives was extremely helpful in tracking down specific views of buildings on the Western campus and allowing us to add a few to the Smith Library's collection. I am indebted to Arthur Miller, Oxford's first African American vice-mayor (among other firsts), who donated materials to the Library and provided answers to numerous questions.

Thanks go to Dr. Robert T. Rhode, professor of English at Northern Kentucky University and author on the steam-power era, for sharing his expertise on farm machinery. I am also grateful to Robert E. White, former *Oxford Press* editor and publisher, whose many years in Oxford make him a valuable source of information. Additionally I want to thank Dr. Phillip R. Shriver, president emeritus of Miami University, for his suggestions on the Miami chapter and Dr. Curtis Ellison, Miami professor and former dean, for similar assistance on the Western College chapter.

Library Assistants Terry Beck and the late Sheila Aranyos deserve thanks for answering my telephone questions with the same professionalism that is extended to all Smith Library users. I am also very grateful to Bill Hudgins, the Lane Public Libraries Technology Trainer, for his assistance with the digital image reproduction.

And special thanks go to my husband J. and sons Joseph and James for all their support (and computer assistance) even though this project took considerably longer than expected.

INTRODUCTION

Native Americans, including the Miami and Shawnee, had shared the rolling hills of the Miami River Valley for generations before they were banished from the region by the Treaty of Greene Ville in 1795. By the time Miami University was named for the indigenous people, descendants of European immigrants had already begun to settle in the area.

Unlike other midwestern towns, Oxford's location was not determined by a stagecoach stop, a watercourse, or a railroad junction. Instead, the site in southwestern Ohio was chosen in a different manner. When Ohio legislators decided to establish a second public university in the early years of the nineteenth century, they wanted it to be in the western portion of the state because Ohio University in Athens was already serving eastern Ohio.

And so it happened that in 1809 Miami University was chartered by the state legislature, trustees were appointed to the board, and three commissioners were assigned to select a site for the new educational institution. To end the squabbling among competing cities and towns, the legislators instructed the new trustees to find a location in northwestern Butler County within the wooded lands that had been set aside by the state in 1803 for the financial support of education. A committee selected a site on a hill overlooking the creek valley where a few hardy pioneers had recently settled.

In 1810, the Village of Oxford was laid out in a "one mile square" with Miami University's campus within its boundaries, and lots were sold. The following year, a small grammar school was built, and the first residents began clearing trees and building log homes. By 1824, a university building had been constructed, and qualified students had been recruited so that Miami University could finally open.

Six years later with a population of over 700, Oxford was incorporated and continued to attract educational institutions. Miami University, the Oxford Theological Seminary, the Oxford Female Institute, the Western Female Seminary, and the Oxford Female College were all operating in the years before the Civil War, making Oxford, Ohio, a true college town much like the city in England for which it was named.

A small city today, Oxford has a rich history and is fortunate to have the Smith Library of Regional History as a part of the Lane Public Libraries. Thanks to the generosity of the family of William E. and Ophia D. Smith and many other contributors, the Smith Library houses a growing collection of books, journals, newspapers, maps, manuscripts, and other related resources. Its outstanding photograph collection is featured here in the pages of this volume of the *Images of America* series. The Smith Library's visual images included in this work provide the basis for an overview of Oxford's history from the early nineteenth century to the mid-twentieth century. As Oxford continues to grow and the Smith Library's photograph collection

continues to expand, there exists the possibility that a future book could include another 50 to 100 years of Oxford history.

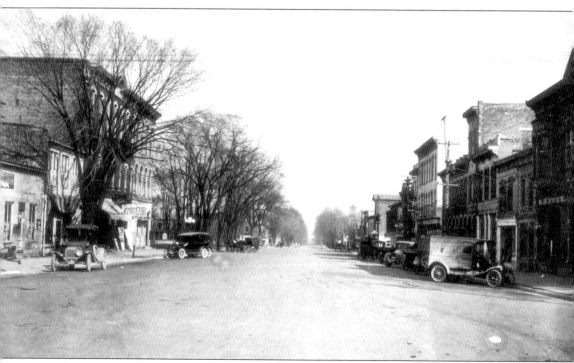

This postcard view of West High Street shows Oxford's uptown business district as it looked in the early years of the twentieth century. The three blocks shown here between Beech Street and Poplar Street were paved with brick about the time of World War I.

One
FIRST A UNIVERSITY

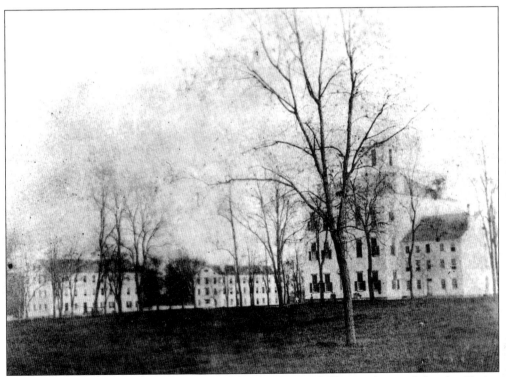

In 1809, Miami University was chartered by the State of Ohio and named for the Native Americans who had previously inhabited the area. By 1818, the first section of the main academic building was completed on the University Square and named Franklin Hall. It can be seen here as the small wing on the large building at the right.

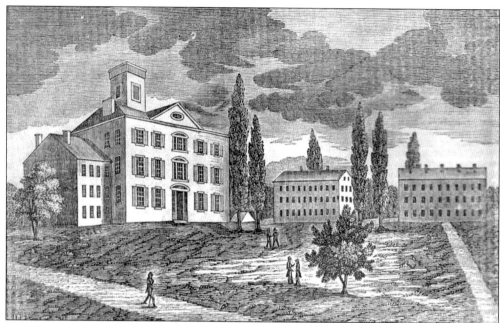

An addition to Franklin Hall, topped with a cupola, was completed in 1824. Initially called the Center Building (and coated with whitewash), it housed a chapel, library, recitation rooms, and meeting halls for literary societies. The North dormitory (center) was built in the 1820s and was followed by the South Dormitory (far right) in the 1830s. Both were renovated in the 1930s and given the names Elliott Hall and Stoddard Hall, respectively.

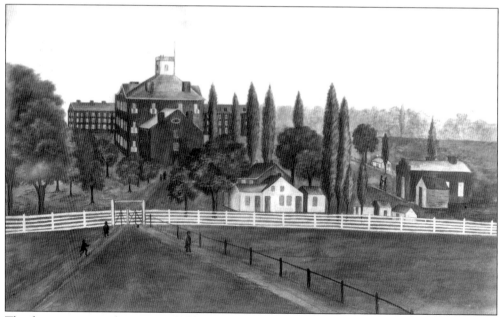

The first university classes were held in 1824 soon after the arrival of Miami's first president, Robert Hamilton Bishop. The "president's mansion" (center foreground) was actually a log schoolhouse that had been enlarged, sided, and painted. Fourteen years later, a one-story science laboratory (far right) was constructed and was known for most of its 60 years as "Old Egypt."

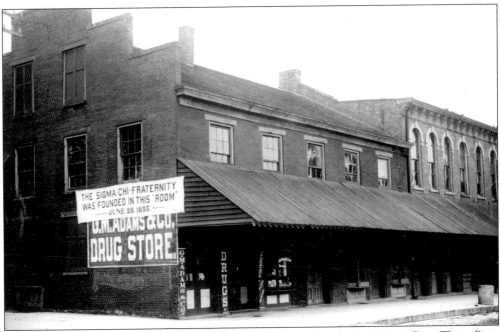

In the years prior to the Civil War, three fraternities were founded at Miami: Beta Theta Pi in 1839, Phi Delta Theta in 1848, and Sigma Chi in 1855. Known as the Miami Triad, these fraternities spread to other colleges, earning Miami the appellation "Mother of Fraternities." Sigma Chi had its beginnings in a student's room above this store at 20 East High Street.

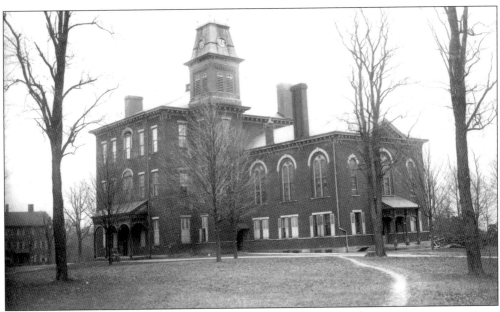

Nicknamed "Old Main," the largest building on Miami's campus underwent a major renovation after the Civil War. The original Franklin Hall portion was removed and replaced by a new west wing. A tower was added, and red paint was applied to the exterior whitewash. An improved appearance, however, was not enough to prevent impending bankruptcy brought on by low enrollment during and after the War. In 1873, Miami closed for 12 years.

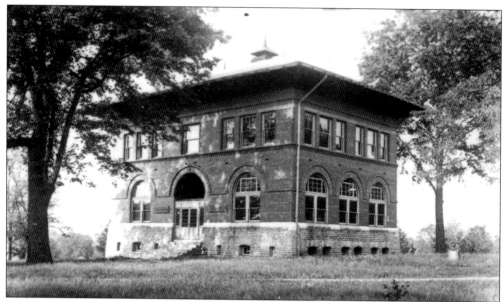

With Miami's reopening in 1885 and the availability of state aid, new buildings began to appear. Shown here is Brice Scientific Hall, which was constructed in 1892. Funding came from the state and from Calvin Brice, a Miami alumnus and U.S. senator, who had made his fortune in railroads. Brice Hall was enlarged in 1905 and razed in 1970 to make room for the construction of King Library.

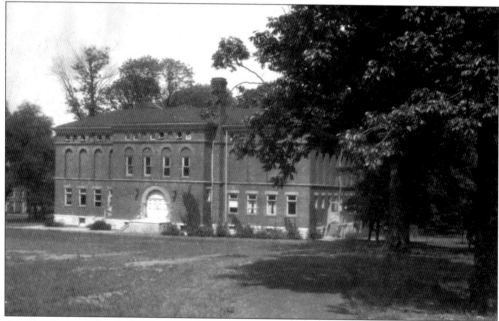

A gymnasium with an elevated running track was completed in 1897 and named for John W. Herron, University trustee and father-in-law of U.S. President Taft. In 1923, the building was moved in order to meet the requirement of a donor who stipulated that *her* new building (Ogden Hall) be located west of Herron Gymnasium. Herron was later renamed Van Voorhis Hall, listed in the National Register, and razed in 1986.

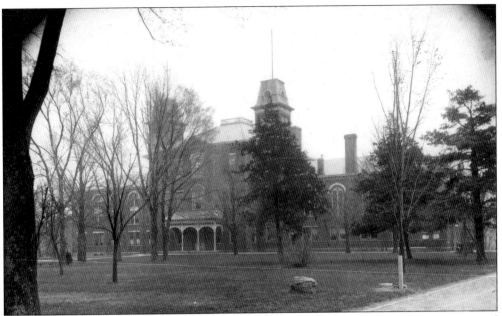

In 1898, another major construction project altered "Old Main." An east wing and a second tower were added (at left). In the 1930s, the building was renamed Harrison Hall in honor of 1852 Miami graduate Benjamin Harrison, who served as U.S. President from 1889–93. In 1958, the building was torn down to make way for a new Harrison Hall.

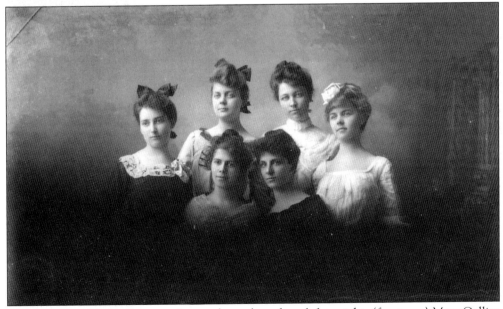

The founders of Delta Zeta sorority are shown here from left to right: (front row) Mary Collins and Mabelle Linting; (back row) Julia Bishop, Anne Simmons, Anna Keen, and Alfa Lloyd. The sorority was established by these Miami students in 1902 and today has chapters throughout the country. Delta Zeta's national headquarters moved to Oxford in 1983.

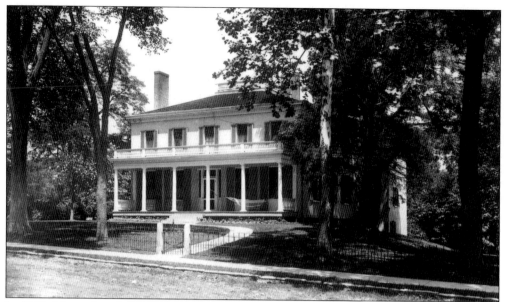

In 1903, Miami found the perfect "White House" for its presidents. Located at 310 East High Street, it was directly across the street from the University Square. The handsome dwelling had been built by Jane and Romeo Lewis in the 1830s. Miami rented the house from Lewis heirs before purchasing it in 1929. Lewis Place has now served as the home of Miami presidents for over a century.

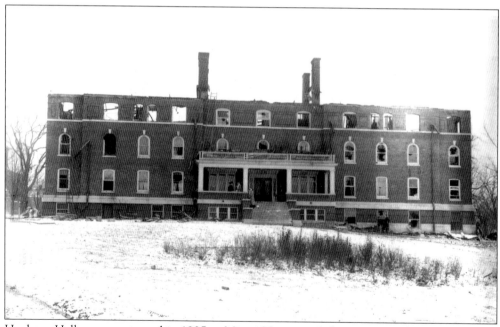

Hepburn Hall was constructed in 1905 as Miami University's first women's dormitory. (It was ironically named for a faculty member who opposed admitting the first women students in the 1880s.) After a fire in 1908, it was rebuilt and continued to serve as a dorm until 1961. Renamed Clokey Hall, it was used for music practice until its demolition in 1972 when King Library was enlarged.

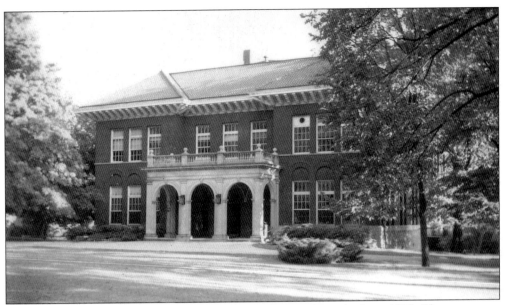

The Administration Building (also called the Auditorium) was built in 1908. The new space provided offices for the president and deans and an assembly hall large enough to accommodate all 700 students. In 1926, it was named Benton Hall to honor Miami's 12th president, and in 1969, its name was changed to Hall Auditorium to honor Miami's fifth president. (The name Benton was then given to another building.)

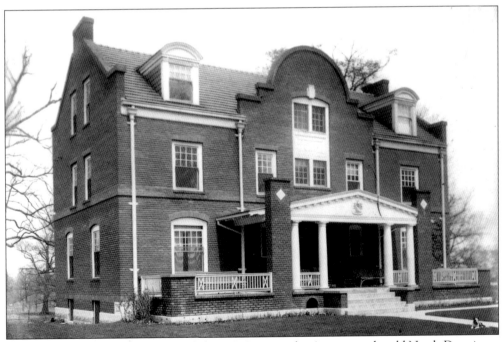

Phi Delta Theta fraternity was founded in 1848 in a student's room in the old North Dormitory. In 1908, this chapter house was built on land leased from Miami on the north side of High Street, the first of three that would comprise Miami's original "Fraternity Row." Less than half a century later, the growing University needed the property, and the fraternity houses were demolished.

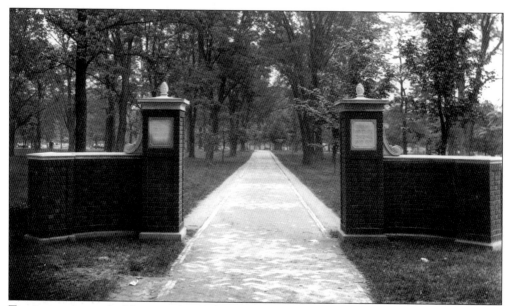

To commemorate the University's 100th year, Centennial Gates were erected in 1909 as a gift from the previous year's graduating class. Located at the northwest corner of the campus, the gateposts framed the entrance to Slant Walk, the diagonal path through campus. The brick sentinels were replaced in 1973 at the request of a fraternity that wanted to commemorate its own anniversary with a new, larger version of the gates.

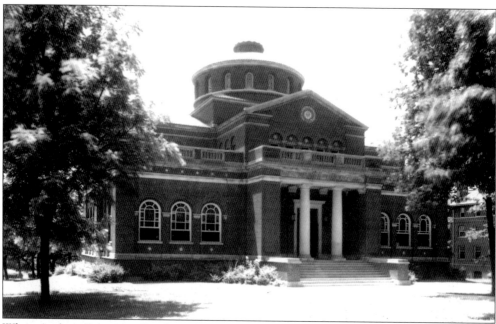

When Andrew Carnegie offered money to construct libraries if matching funds could be raised, Miami University alumni accepted the challenge. The result was the appropriately named Alumni Library, which opened in 1909 and served Oxford residents as well as university students and faculty. An east wing was added in 1924 and a west wing in 1955. It was renamed Alumni Hall after it was no longer used as a library.

16

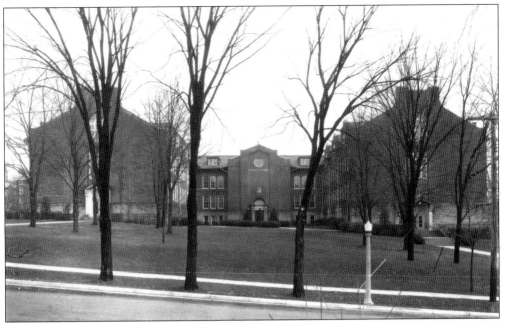

McGuffey Hall, built in stages, was named for the early Miami professor who wrote the famous *McGuffey Readers*. The south wing was completed in 1910, the north wing in 1915, and the central connector in 1916. A gymnasium was added in 1925 for the university's laboratory school, which occupied part of the building.

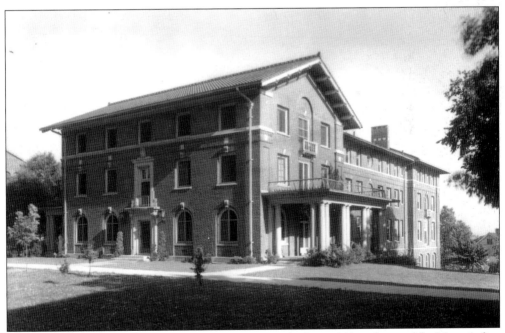

Bishop Hall, Miami's second women's dormitory, was built in 1912 and named for Miami's first president. During the flu epidemic of 1918, it also served as the university's hospital. Its location near Hepburn Hall put the women's residence halls on the west side and the men's two residence halls on the east side of the area that comprised the main part of campus.

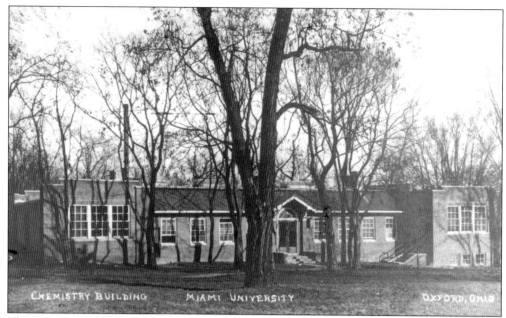

The one-story, red brick Chemistry Building was constructed in 1914. Located southeast of Stoddard Hall, this laboratory and classroom facility was used until 1938 when it was razed to make way for an addition to Hughes Hall to the east.

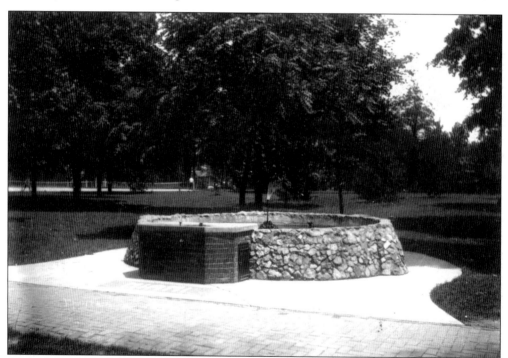

Around the time of World War I, Oxford bricklayer Harry Thobe designed and built a large stone and brick fountain for the University. Located next to Slant Walk, this campus landmark underwent major alterations in the 1950s and was removed by 1970. A marker and bench commemorating Kappa Kappa Gamma sorority now occupy the site.

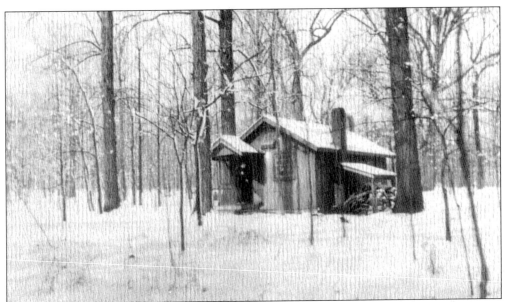

The "Poet's Shack" in the woods of Lower Campus was built in 1920 for Percy MacKaye. The recipient of an artist's fellowship, MacKaye was the first artist-in-residence at Miami. The cabin was built for him as a quiet refuge where he could write poetry and discuss his craft with students. After his departure, the small building fell into disrepair and was razed in 1934.

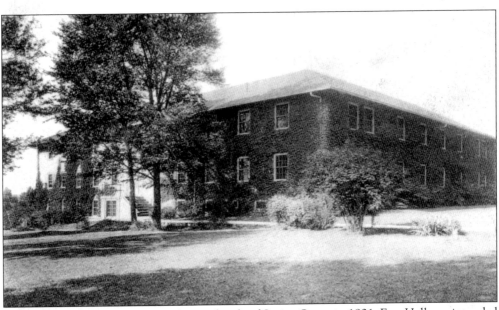

Built as a women's dormitory on the south side of Spring Street in 1921, East Hall was intended to be temporary. After housing WAVES during World War II, it was renamed Stanton Hall in honor of Miami's sixth president. Oxonians also remembered him as the brother-in-law of Elizabeth Cady Stanton, who lectured in Oxford in 1870. In 1961, the building was razed to make room for Warfield Hall.

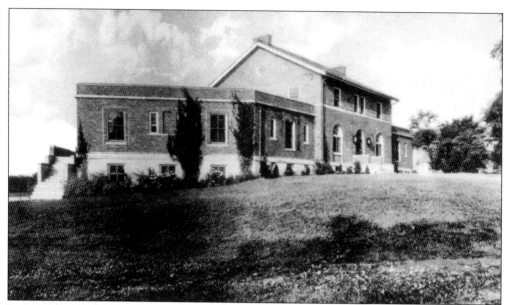

In 1923, Miami built McMillan Hospital on East Spring Street. Named for the university's health director, the 99-bed facility provided medical care for a student population that had grown to over 1,500. (Although Oxford's population was over 2,000, it would be more than 30 years before the Village would have its own hospital.)

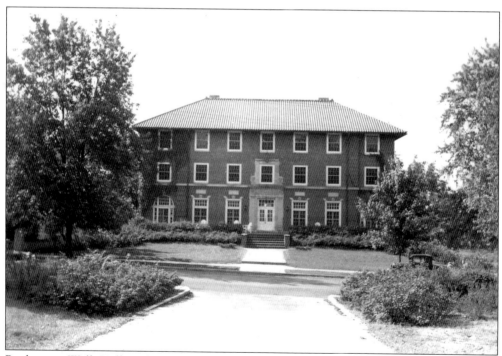

By the time Wells Hall was built in 1923, women students made up over half of Miami's student body. This new women's dormitory was erected on the south side of Spring Street almost opposite Bishop Hall. The new residence hall was named for a businessman who lived in Oxford as a boy and left a bequest to Miami.

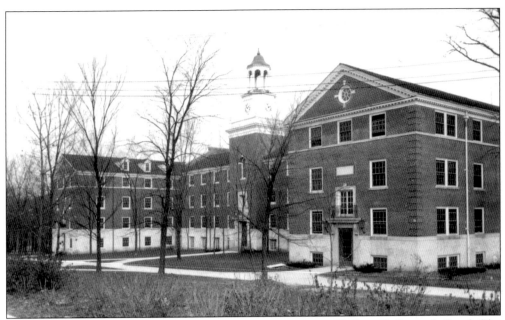

The first residence hall built north of High Street was Swing Hall on Tallawanda Road. The south wing was completed in 1924, and the north and central sections were added in 1935. This men's dormitory was named for a Miami graduate of 1852 who became an acclaimed Chicago minister. During World War II, Swing Hall housed military personnel who were members of the V-12 program.

Between the First and Second World Wars, Miami grew beyond the original quadrangle as new buildings were constructed to the east, south, and north. One notable addition was the McFarland Observatory. Named for a Miami University astronomy professor and president pro tempore, the building was erected in 1925 close to where the Shriver Center stands today. In 1959, the Observatory was dismantled and moved to Delphos, Ohio, where it fell into disrepair.

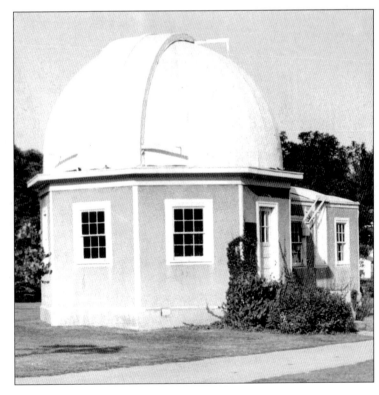

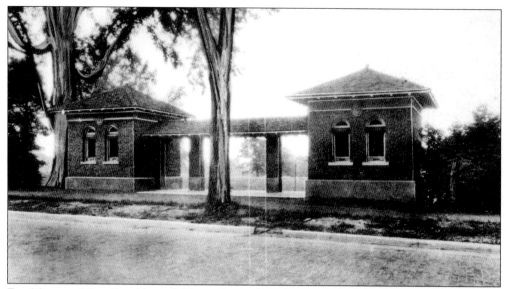

For 86 years, Miami's athletic field was located at the northwest corner of High Street and Patterson Avenue. Beginning as a grassy field with a board fence, the facility eventually had a quarter-mile track and steel bleachers. In the 1920s, these brick ticket gates were erected at the entrance, and it was here that intercollegiate football games and track meets were held until the facility was demolished in 1982.

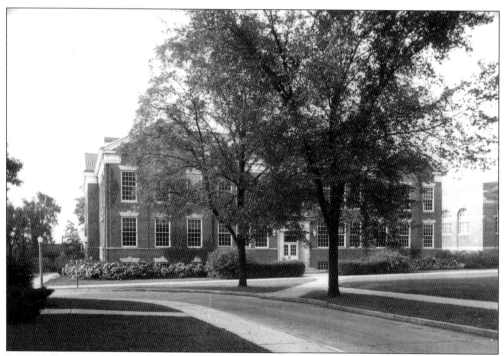

Irvin Hall was built in 1925 with a south wing completed in 1928. Named for a man who had served on Miami's Board of Trustees for almost 30 years, the red brick building was designed with faculty offices on the inside corridor and classrooms around the perimeter of each floor. Irvin Hall was located just east of Alumni Library on what had been a tennis court.

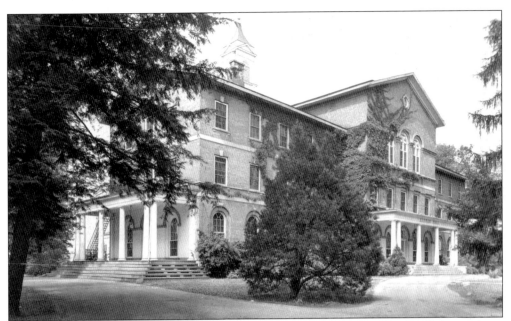

In 1925, Miami purchased property that had been an asylum for the mentally ill. Located just east of the village limits, Fisher Hall was the name given to this men's dormitory to honor a Miami alumnus and member of the Board of Trustees. (A student's disappearance from here in 1953 remains unexplained.) Fisher Hall was razed in 1978 to allow construction of the Marcum Conference Center on the site.

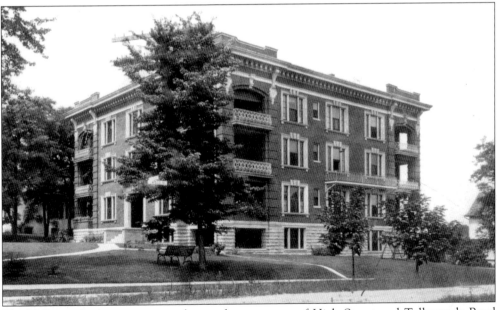

The Tallawanda Apartments on the northwest corner of High Street and Tallawanda Road were privately built in the early 1900s. In 1929, a restaurant called Tuffy's opened in the basement and became famous for its toasted rolls. Miami leased the apartments for use by students and faculty before purchasing the property in 1952. Used as a women's dormitory until its demolition in 1984, the building was replaced by a parking lot.

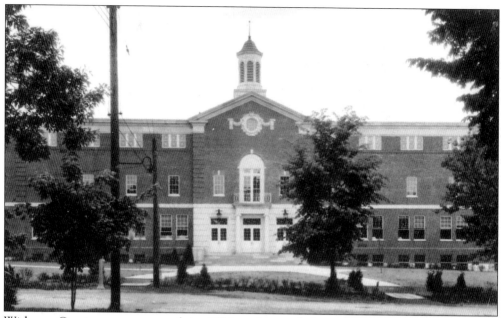

Withrow Court was constructed in 1931 and named for a long-time trustee of Miami University. Located on Tallawanda Road, it was built to serve as a gymnasium for classes and recreation and as an assembly hall for a student body of over 2,000. The facility was also used for intercollegiate basketball, formal dances, and commencement exercises.

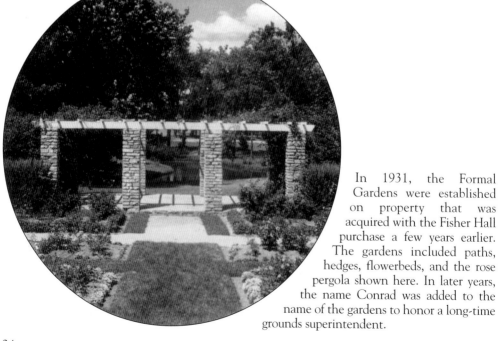

In 1931, the Formal Gardens were established on property that was acquired with the Fisher Hall purchase a few years earlier. The gardens included paths, hedges, flowerbeds, and the rose pergola shown here. In later years, the name Conrad was added to the name of the gardens to honor a long-time grounds superintendent.

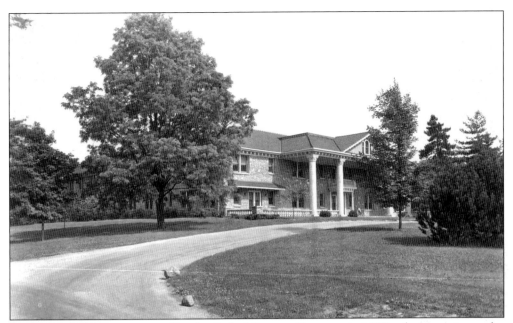

This stone building was erected by the Oxford Retreat Company in 1927 to house patients who were being treated for alcoholism and other substance abuse. Located at the east end of High Street, it became a university dormitory when Miami purchased the property in 1936. It was first called the Pines (after an earlier residence on the site) and later named Wilson Hall in honor of a Miami University administrator.

In 1939, to celebrate the centennial of its founding at Miami, Beta Theta Pi national fraternity presented four large bells to the University. Until a bell tower could be completed, the bells occupied the east tower of Harrison Hall. By the time the Beta Campanile was dedicated in 1946, the Beta Bells, as they became known, could be heard chiming each quarter hour from almost anywhere in Oxford.

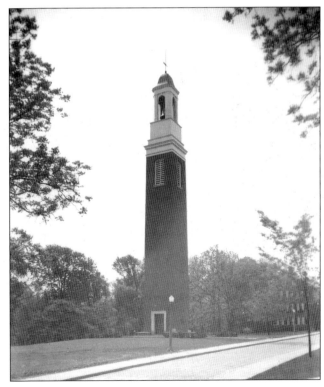

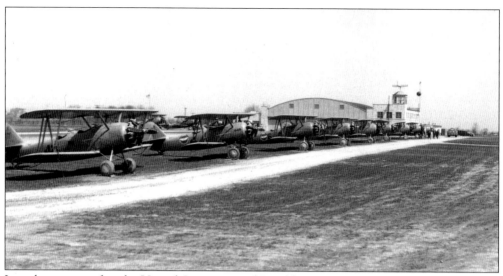

Less than a year after the United States entered World War II, Miami acquired property west of Oxford for the development of an airfield for pilot training. By mid-1943, a permanent building was under construction. The new Williams Hangar was named for a 1936 Miami graduate who died in the attack on Pearl Harbor. He was Oxford's and Butler County's first casualty of the war.

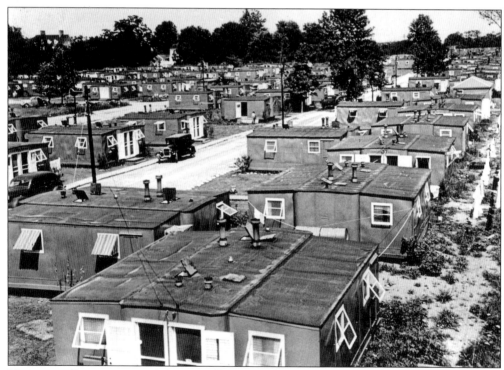

Miami enrollment increased dramatically after World War II as a result of the GI Bill. To accommodate married veterans and their families, these prefabricated housing units were erected between Oak Street and South Campus Avenue. Although its official name was Veterans Village, the area was usually called just "Vetville."

Two

A SEMINARY FOR MEN
AND AN INSTITUTE
FOR WOMEN

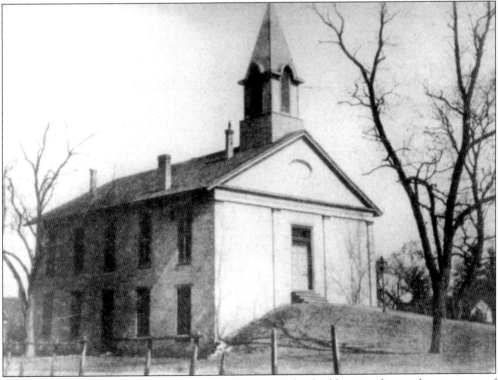

The Oxford Theological Seminary opened in 1839 in this building on the northeast corner of East Church and North Poplar Streets. (The earthen embankment led to the second floor where the congregation of the Associate Reformed Church met.) The young men who were studying for the ministry occupied the lower level where their classrooms, library, and living quarters were located. In 1858, the Seminary moved to Monmouth, Illinois.

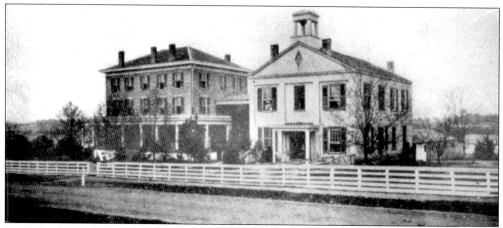

In 1849, the Oxford Female Institute was established under the leadership of John W. Scott with the support of Oxford's First Presbyterian Church. The following year, a two-story building with a cupola was erected on what would later be called South College Avenue. In 1856, a three-story residence hall was built just south of the original building, which housed the chapel and classrooms. A covered walkway connected the two buildings.

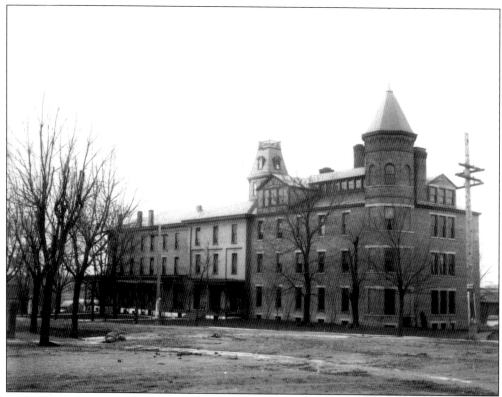

By 1867, declining enrollment forced the Institute to merge with its rival, the Oxford Female College, located northeast of the Village. In 1882, the debt-ridden Female College sold its large campus, and the students returned to the Institute's old connected buildings. These buildings are shown here after several major additions and alterations changed their appearance in the 1880s and 1890s.

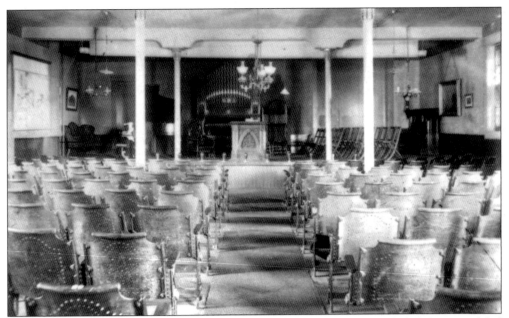

Interior changes to the academic buildings on South College Avenue included this remodeled chapel with an organ along with meeting rooms, art galleries, practice rooms, and a dining hall. Morning and evening worship services were held in the chapel and included a prayer led by the college president. With seating for the entire student body, the chapel was also used for lectures, concerts, and theatrical productions.

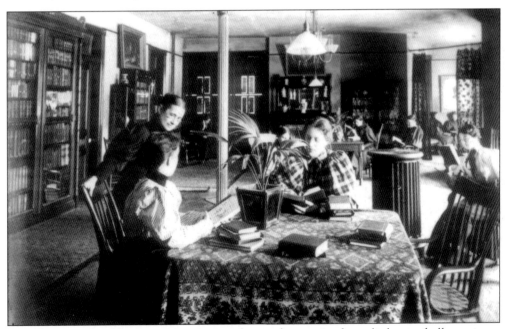

In addition to this library, a new wing to the north contained a calisthenics hall, a science room, more bedrooms, and an elevator. With close to 200 students enrolled, the College began conferring bachelor's degrees in 1886. In 1890, the word "female" was dropped from the name, and in 1906, a new charter was granted under the name Oxford College for Women.

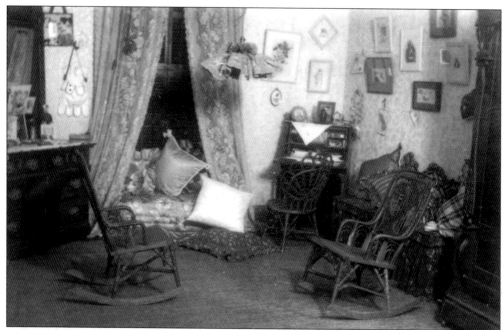

Most students at Oxford College shared double rooms, which the college furnished with a bureau, washstand, wardrobe, carpet, and beds. Each student was permitted to do her own decorating, and this bedroom was typical of those of the early 1900s.

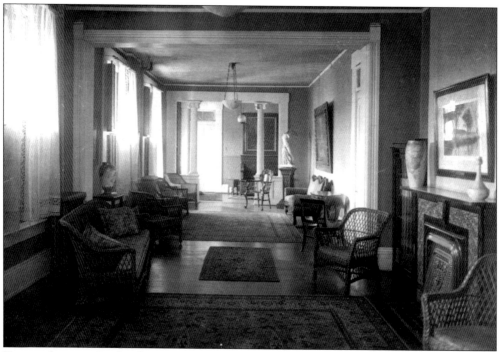

For socializing with schoolmates or entertaining visitors, Oxford College students had the use of several parlors. Each parlor was formally furnished, and some were designated for use by a particular class: seniors, juniors, etc.

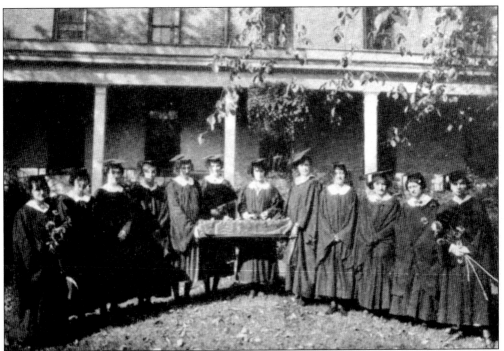

Oxford College students began wearing caps and gowns in 1890. Initially the academic vestments were worn on the street, but eventually they were reserved for commencements and other special occasions.

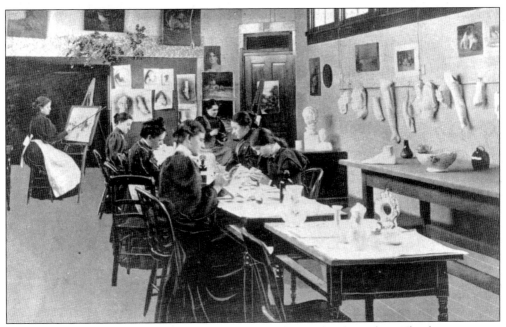

Art classes were offered at Oxford College as part of the regular curriculum. The decorative arts included instruction in portraiture, china painting, and watercolors. Located on the fourth floor of the west-wing addition, the art studio was spacious and well lighted.

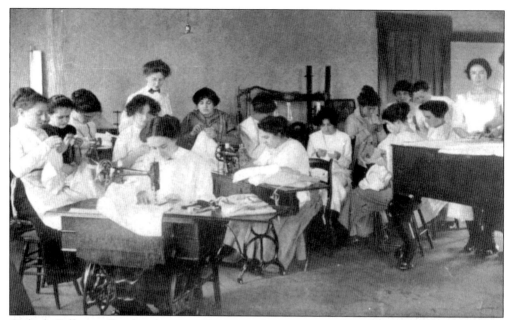

Oxford College offered courses in Domestic Science as early as 1908 and by 1911 had established a recognized Department of Home Economics. This department began in the basement of the main building but eventually moved to a larger facility across the street.

Originally the boiler house for nearby Oxford College, West Cottage was remodeled for use by the Home Economics Department. It was located on the west side of South Elm Street, a short walk from the main building. Later called Blanchard House, it was razed in 1972.

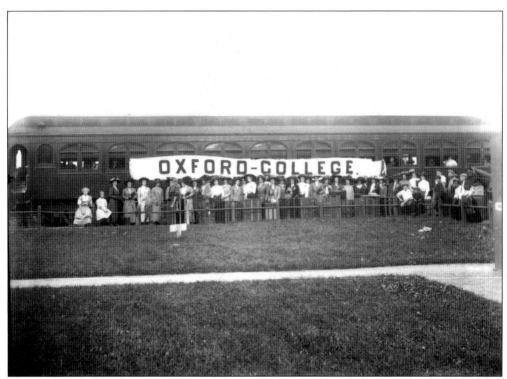

Any student traveling from a distance generally arrived in Oxford by train. Special railroad cars were reserved for Oxford College students, and this group posed in front of their car in 1909.

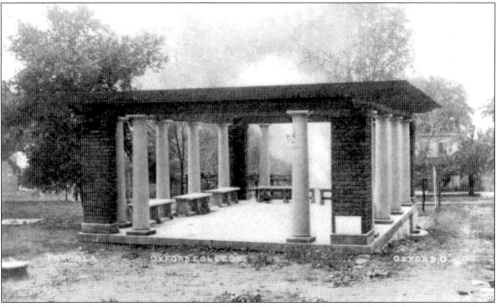

In 1911, a pergola was erected on the Oxford College grounds just behind the main building. In warm weather, it functioned as an outdoor recitation room and as the backdrop for plays and parties. The campus eventually included the entire block bounded by College Avenue, High Street, Elm Street, and Walnut Street plus several adjacent properties.

The presidents of Oxford College lived in the main college building along with students and faculty until 1913, when the college acquired this house on the northeast corner of South College Avenue and West Walnut Street. Known as Senior House, the residence provided dormitory space for seniors as well as an office and living quarters for the college president.

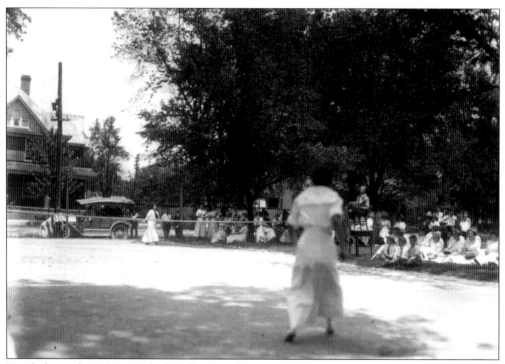

Until the early 1900s, Oxford College students were required to participate in an outdoor exercise regimen every afternoon. In later years, a tennis court on the campus provided recreational opportunities for the women and on special occasions attracted spectators.

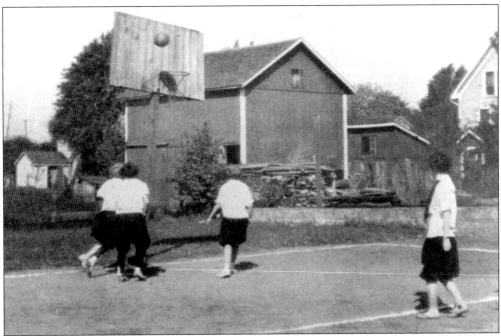

By 1912, Oxford College had acquired an athletic field just west of Elm Street. Named for a professor, Wilson Field provided the necessary space for basketball, hockey, and more tennis. Intramural sports were an integral part of the extracurricular life at the College.

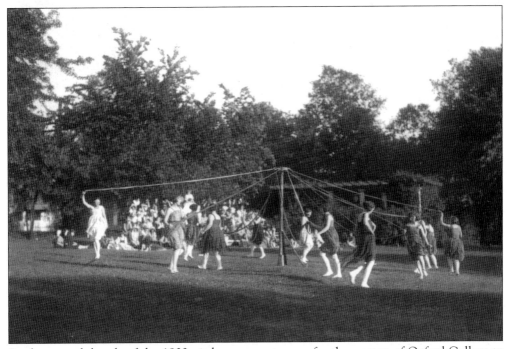

By the second decade of the 1900s, it became customary for the women of Oxford College to hold a spring celebration called the May Fete. This outdoor event included pageants, masques, and the crowning of a May Queen.

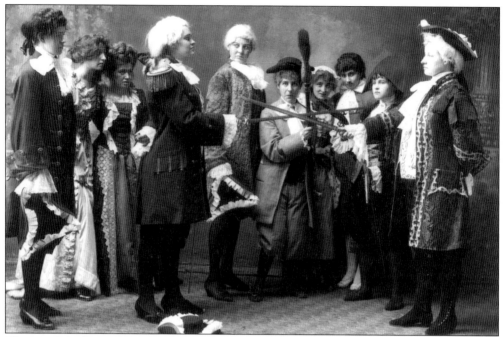

Theatrical productions were a popular form of entertainment at Oxford College. The women students played all the roles and spent a great amount of time and effort creating elaborate costumes and sets.

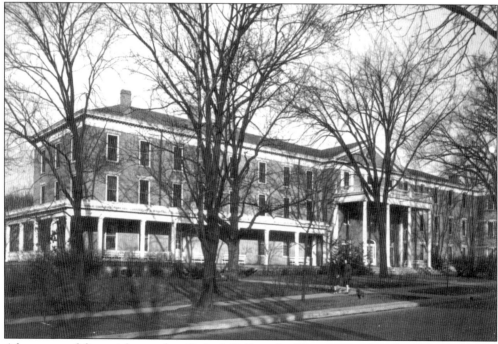

After years of financial struggles, Oxford College for Women was forced to close in 1928. Miami University assumed the school's debts and acquired its property that same year. After remodeling the building, Miami used it as a women's dormitory for almost 70 years.

Three
TWO MORE SCHOOLS
FOR WOMEN

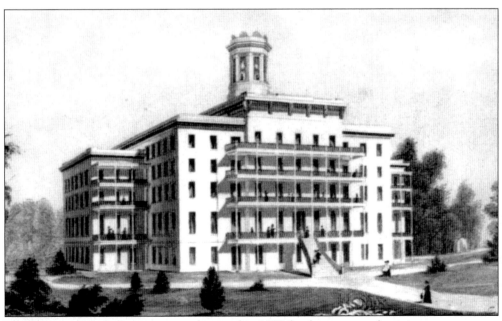

The Western Female Seminary was chartered in 1853 for the purpose of training young women to be teachers or missionaries. The name was chosen because the school was modeled after Mount Holyoke Seminary in Massachusetts, but it was located in the western part of the country. The Seminary, on the east edge of Oxford, opened in 1855 under the leadership of Helen Peabody, a graduate of Mount Holyoke.

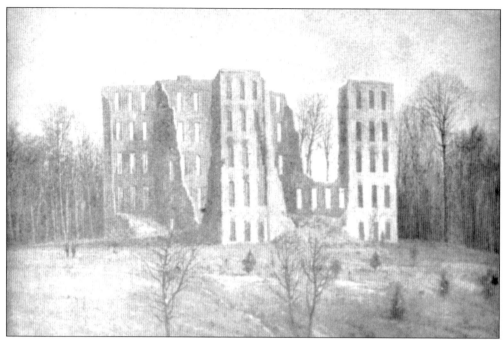

One January night in 1860, a defective flue caused a fire that spread throughout the Western Female Seminary building. The students and teachers escaped without injury and even saved some of the furniture. By the time a bucket brigade was organized by Oxford men, it was too late to save the building.

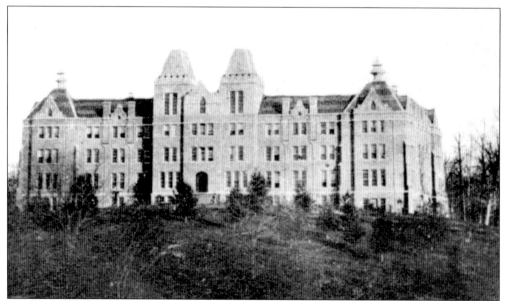

By the fall of 1861, with continued support from Oxford's Second Presbyterian Church, a new brick building had been constructed on the campus of the Western Female Seminary. An imposing edifice with a slate roof, two wings, and a rear courtyard, it was described as resembling something from the Middle Ages and was typical of early institutions for advanced education of women.

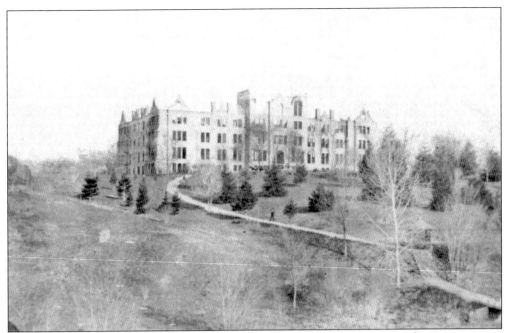

In April 1871, the Western Female Seminary burned a second time. This fire was caused by an oven in the kitchen, and once again, all the students and faculty were evacuated safely. Village firefighters extinguished the blaze, but very little was left other than exterior walls.

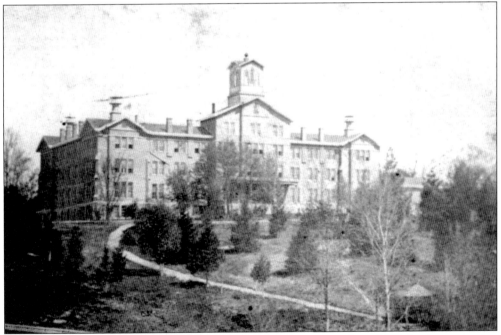

The third Western Female Seminary building was constructed in 1871 by incorporating exterior walls from the second building. This edifice survived as the main building at "The Western" for many years and in 1905 was named Peabody Hall in honor of the school's first principal. (The building underwent a major renovation in 1996.)

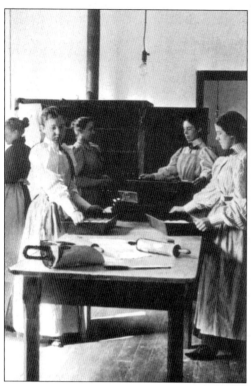

In order to minimize the cost of room and board, the Western Female Seminary adopted Mount Holyoke Seminary's "domestic system." Instead of hiring workers, the Seminary required that each student spend approximately one hour each day preparing food, cleaning rooms, or washing dishes. This system remained in effect until about the time of World War I.

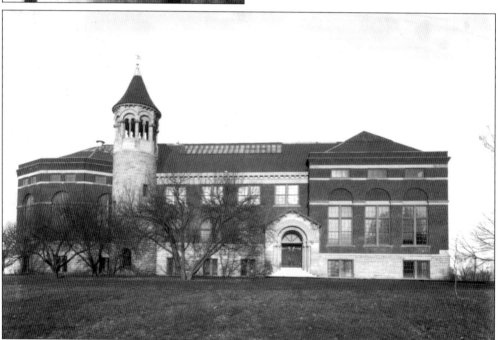

In 1892, Alumnae Hall was dedicated on the campus of the Western Female Seminary. The new building housed science laboratories, art studios, a library, and a lecture hall. Within three years, the first bachelor's degrees were granted as the institution made the transition from a seminary to a college. (The building was razed in 1979.)

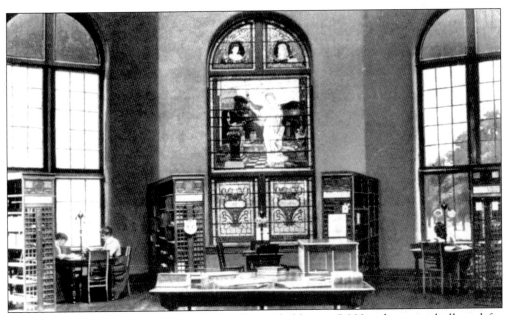

In its new quarters in Alumnae Hall, the library held over 5,000 volumes and allowed for growth. The spacious room, dodecagon in shape, included a large, stained glass window given by the building's major donor to honor an earlier graduating class. This window, exhibited at the World's Columbian Exposition in Chicago in 1893, was later moved to Kumler Chapel.

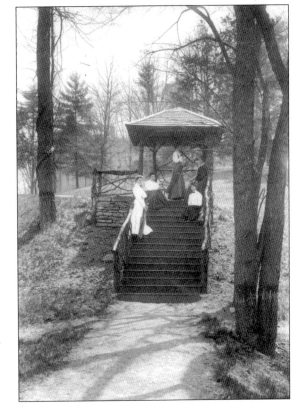

The Western campus included many areas of natural beauty, and in the early years, students were required to spend time outdoors each day. The Summer House, shown here in an1890s photograph, was a destination for walks and a gathering place for students. In later years, columns built of stone replaced the corner supports made of wood.

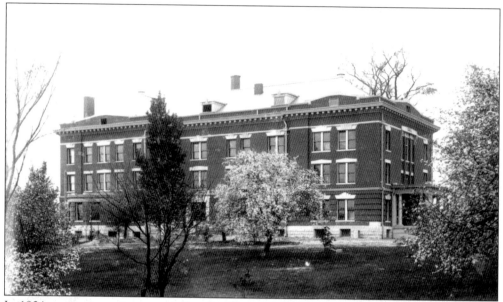

In 1904, two major events occurred at the Western. One was the changing of the name of the institution to the Western College for Women. The second event was the dedication of the first separate residence hall to be built on the campus. This dormitory would later be named McKee Hall in honor of the seminary's second principal, who also served as the college's first president.

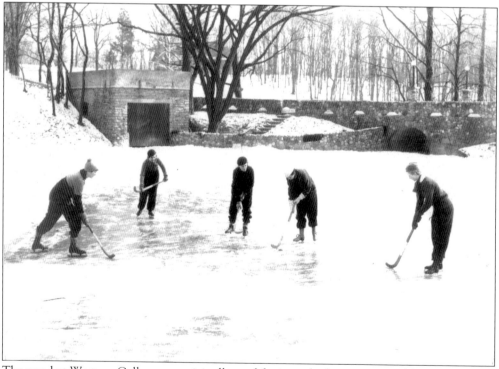

The pond at Western College was originally used for ice, which was cut into blocks and stored in a nearby icehouse. In later years, the pond was a favorite place to skate in cold weather and to feed ducks in warm weather. The structure at the edge of the pond was called the boathouse.

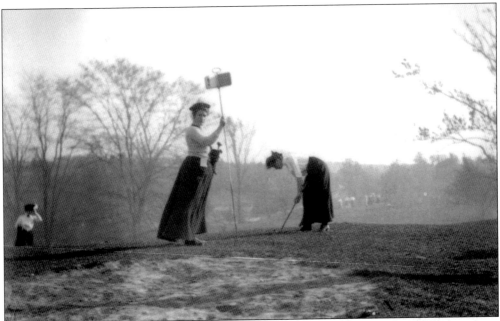

Athletic activities were an important part of students' lives at Western College. These students played golf on what was only the third course laid out on any American college campus. Tennis, basketball, and baseball were also popular sports.

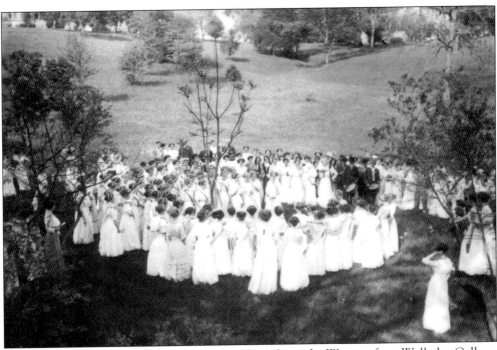

Tree Day was an annual spring event that was brought to the Western from Wellesley College. Beginning in 1890, the festivities included planting a new tree, raising class flags, and singing school songs. The tradition was well established when this picture was taken in 1911 and would continue until after World War II.

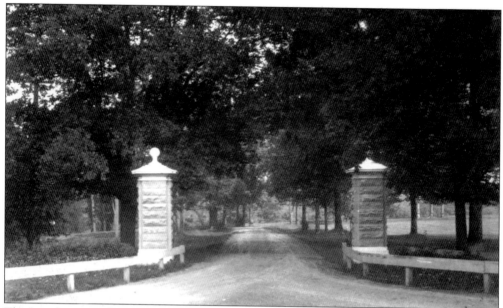

This was the original entrance to the Western campus near the south end of Patterson Avenue. It was later named Tenney Gateway to honor the Reverend Daniel Tenney of Oxford's Second Presbyterian Church. Later, another entry way was created farther north on Patterson Avenue just opposite the end of Spring Street. In addition, there were smaller stone posts marking the footpath entrance to the grounds.

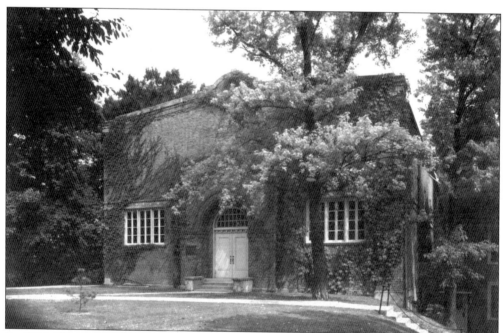

By 1914, Western College had built Sawyer Gymnasium just east of Peabody Hall. Named for a dean who served as acting president of the College, it was furnished with state-of-the-art equipment including rowing machines, flying rings, and a swimming pool. For many years, all students had to complete a swimming requirement in order to graduate.

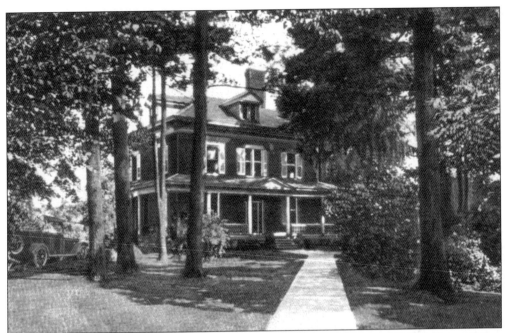

Patterson Place became the residence of Western College presidents in 1914. Built in 1898 as the summer home of the Patterson family, it had originally been called Glenwilde. The house, situated on 70 acres of land that adjoined the campus, was a gift of the Patterson family.

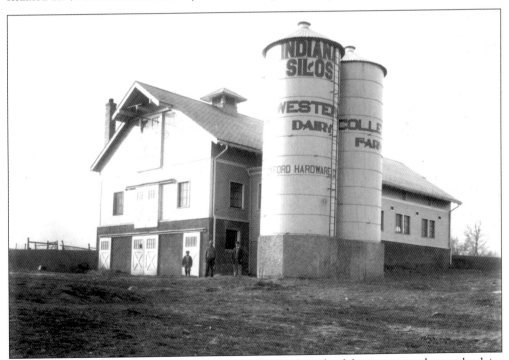

The Western College grounds grew to include farmland south of the campus and a nearby dairy run by a farm manager. During World War I, students grew vegetables, picked fruit, butchered livestock, and canned produce that they had raised.

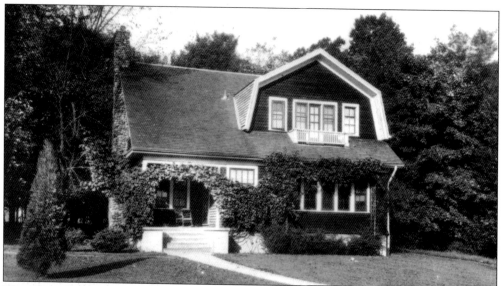

The Edgar Stillman Kelley Studio, named for its first occupant, was located near Patterson Avenue on the Western College campus. Built with funds donated by the graduating class of 1916, it was dedicated in the fall of that year. The cottage included living quarters and a studio large enough for the composer's grand piano. It is believed that Kelley was the first artist-in-residence at an American college.

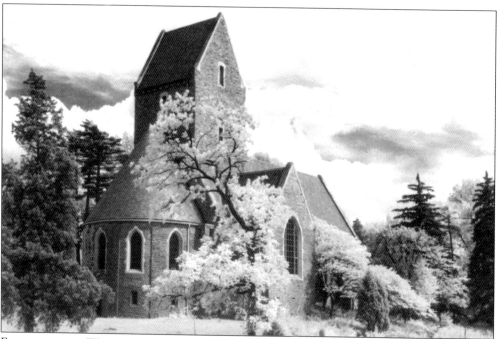

For many years, Western College held religious services in a room in Peabody Hall. By 1918, with 267 students enrolled, a larger space was needed. Two Oxford sisters (one of whom was a Western graduate) donated funds, and it was for their family that Kumler Chapel was named. Although the tower collapsed during construction, the building was eventually completed and featured stained glass windows with religious and academic themes.

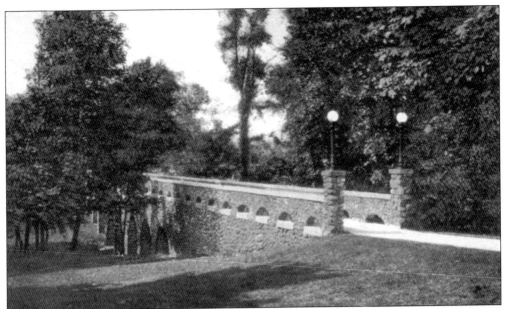

Ten footbridges and more than a dozen lampposts were built during the administration of Western's President William Boyd. All of these were the work of Cephas Burns, a local African American stonemason. Burns personally selected round, smooth stones from nearby creeks for his trademark "cannonball" stonework. He also built parts of Western's Kumler Chapel, Kelley Studio, YWCA Lodge, and buildings on the campus of Miami University.

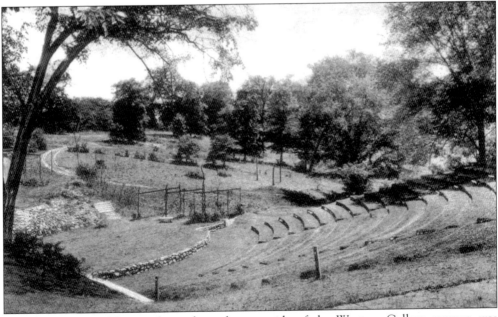

The Ernst Nature Theatre, located on the east side of the Western College campus, was dedicated in 1922. Designed to take advantage of the natural setting, the outdoor performance area was nestled between two hills with stages on two levels and seating for 1,400 people—all carved into the landscape. The donor of funds for the project was Richard P. Ernst, a college trustee and U.S. senator from Kentucky.

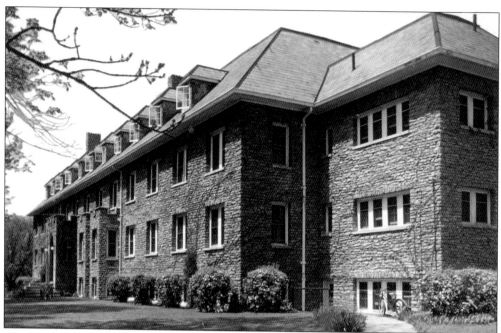

Western College enrollment reached 350 students in 1924, and in the following year, a new dormitory was built. It was later named Mary Lyon Hall in honor of the founder of Mount Holyoke Seminary in Massachusetts, whose educational system was brought to the Western. From 1855 to 1924, Western College always had at least two Mount Holyoke graduates on its faculty.

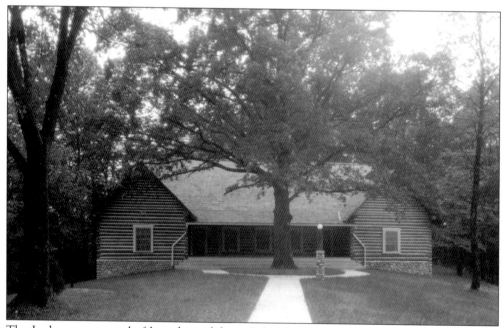

The Lodge, constructed of logs shipped from Colorado, was erected on the Western College campus in 1926. Reminiscent of a hunting lodge, the rustic building included an imposing stone fireplace built by Cephas Burns. Although the Lodge was first used as the YWCA headquarters, it became the student recreation center and later served as a nursery school.

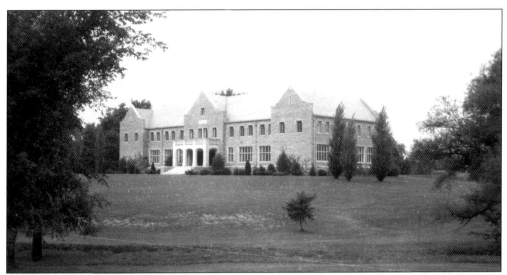

In 1931, a music hall was constructed on the west side of the Western College campus. This imposing stone building was named Presser Hall in honor of Theodore Presser, whose philanthropic foundation provided half of the needed funds. With 750 seats, the auditorium easily accommodated the student body of over 400 as well as members of the public who attended lectures, concerts, and plays that were part of the cultural offerings at the thriving liberal arts college.

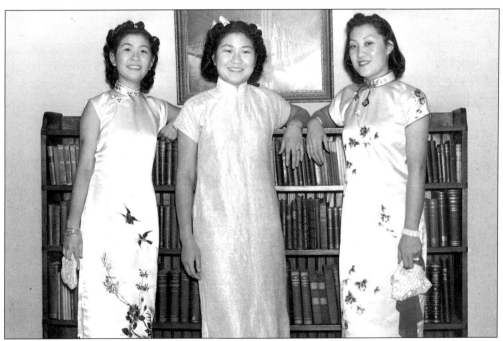

A student from another country came to Western as early as 1902, and by the time these Chinese students were enrolled in the 1930s, the school was well on its way toward establishing a truly international atmosphere. After enrollment peaked at 566 students in 1947, it declined until men were admitted in 1972. In 1974, financial difficulties forced the College to close, and the campus was acquired by Miami University.

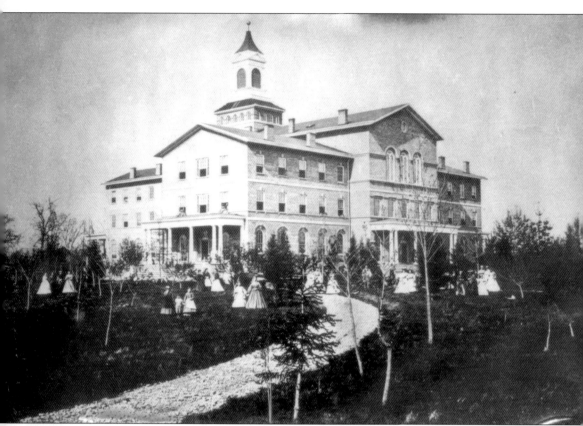

The last of Oxford's three women's schools to be established was the Oxford Female College. Ebenezer Lane, one of the benefactors of Lane Theological Seminary in Cincinnati, donated 34 acres of land near his home on the east side of Oxford. The grand building that was erected with the support of Oxford's Third Presbyterian Church included over 100 rooms for students and faculty, a library, a dining hall, classrooms, society halls, and a chapel that could seat 800 people. Under the leadership of John W. Scott, who had formerly presided over the Oxford Female Institute, the new College opened in 1856 with over 200 students. By 1867, financial difficulties caused the Oxford Female Institute and the Oxford Female College to merge, and for over a decade, the combined student body remained in this large building with its spacious campus. By 1882, overwhelming debt forced the College to sell its property to the Oxford Retreat Company for use as a mental hospital. The students and faculty of the College then moved to the Institute's former buildings on South College Avenue.

Four
OXFORD'S GROWTH
AND DEVELOPMENT

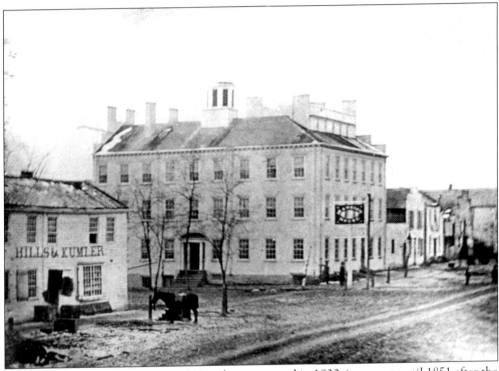

Although Oxford was laid out in 1810 and incorporated in 1830, it was not until 1851 after the Village's population had surpassed 1,111 that the first known photograph was taken. It shows the Mansion House hotel and Hills and Kumler dry goods establishment at the corner of High and South Main Streets. These buildings in the heart of what would become known as Uptown Oxford are no longer standing.

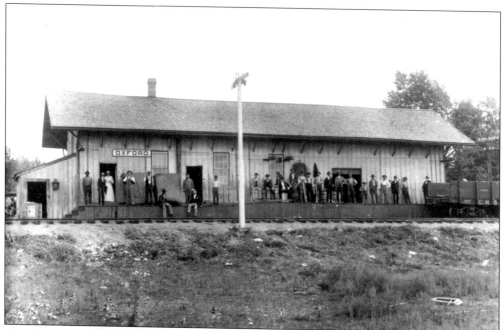

A railroad linking Oxford to Hamilton and to College Corner was completed in 1859. This frame depot was erected just west of the intersection of West Collins and South Elm Streets. Because the train tracks ran directly through the original public burial ground, the bodies had to be moved to new graveyards: the public Woodside Cemetery, the Catholic Mt. Olivet Cemetery, the private Oxford Cemetery.

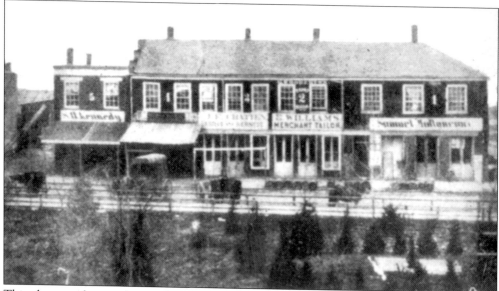

This photograph was taken in the 1860s after Oxford's population had reached 1,839. It shows commercial establishments on the north side of West Park Place. Included are the businesses of a dry goods merchant, a saddle maker, a tailor, and a grocer. The grocer, Samuel Mollyneaux, was a descendant of French Huguenots who had left France to live in Ireland before coming to the United States.

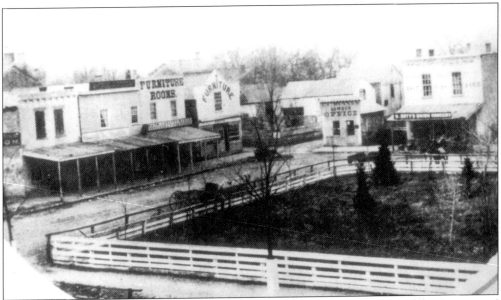

Another 1860s view shows the west side of the Public Square with the fences that were erected to keep wandering animals from rooting up the grass. Nearby businesses included a saloon, furniture stores, a lumber office, and a grocery. The lumber dealer, Thomas C. Munns, came from Ireland in 1820. Within a few years, another business in one of the corner buildings was a barbershop operated by African American Fred Tiester.

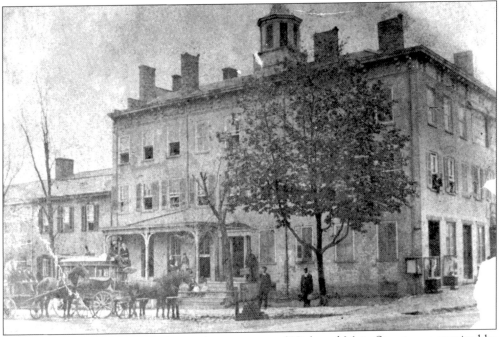

When the Mansion House at the southwest corner of High and Main Streets was acquired by Peleg Cone in 1852, it became known as the Cone House. The front entrance on Main Street is shown with a covered porch. The hotel closed after the Civil War ended, and the building housed other businesses including a bank, a meat market, and a photographer's studio.

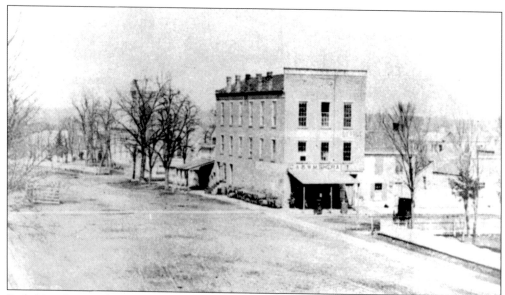

Probably taken in the 1870s, this photograph shows the northeast corner of the intersection of Main Street and East Park Place. In the early years, the Independent Order of Odd Fellows met in their lodge hall on the third floor of this three-story building. Members of the Shera family, who came from Ireland, operated a grocery store on the first floor. The building was razed in the 1920s.

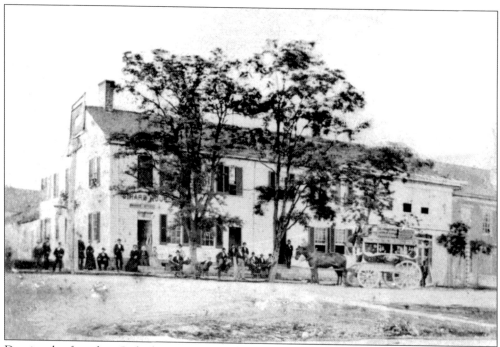

Despite the fact that Oxford's population declined to 1,738 in 1870, businesses continued to prosper. An early establishment called the Oxford Hotel operated at the northeast corner of East High and North Poplar Streets and had been renamed the Girard House by the time this photograph was taken. The horse-drawn coach seen in front brought guests from the train station about seven blocks away.

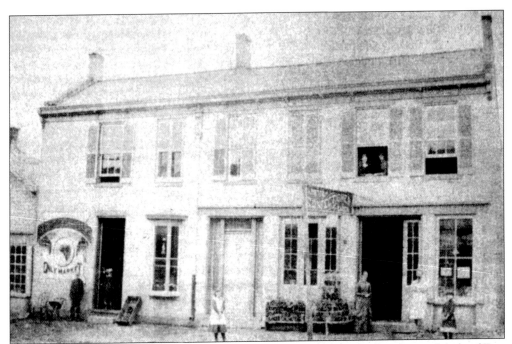

In the years following the Civil War, two businesses occupied this site on the south side of East High Street. At the left was the butcher shop of William Wallace and at the right was the bakery and confectionary of German immigrant August Roettig. Constructed in 1820 as the Stilson Hotel, the building was located between Poplar and Main Streets, just east of the alley.

This building was erected in 1871 on the northwest corner of West High Street and West Park Place. The spacious third floor became the new lodge for the Odd Fellows while the second floor housed offices of dentists and printers. The first floor was always occupied by banks, and at one time, the basement level housed an African American-owned barbershop and hair salon.

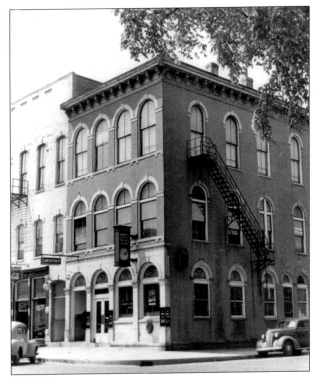

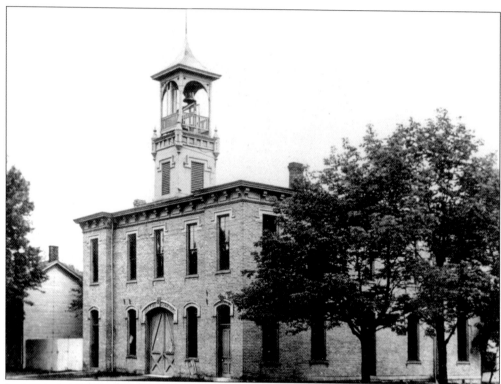

In 1874, the Village of Oxford built a Town Hall on the southeast corner of East High and South Poplar Streets. The upper level served as a public meeting place. The lower level provided rooms for offices and storage space for fire-fighting equipment. The bell in the tower was used to summon volunteer firemen from the East End of town.

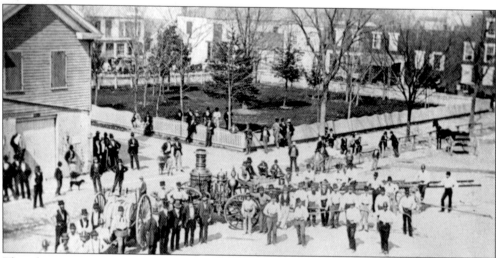

This photograph taken in 1875 shows Oxford's new steam pumper, a better means of fighting fires than the old bucket brigade. At the left is the Market House, which stood in the middle of Main Street between the east and west halves of the Public Square. Used for council meetings and equipment storage before the Town Hall was built, it was removed shortly after this picture was taken

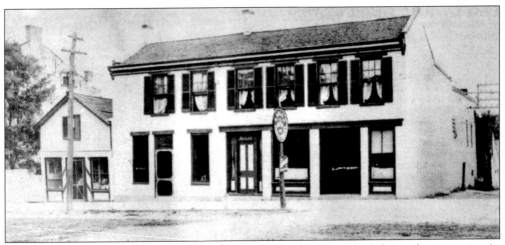

By the late 1800s, the businesses in the old Stilson Hotel building had changed once again. At the right was the bakery of Bernard Ringold from Germany. At the left in the two-story building was the meat shop of German immigrant Ambrose Wespiser. The small building at the far left was occupied by the barbershop of African American Aaron Williamson.

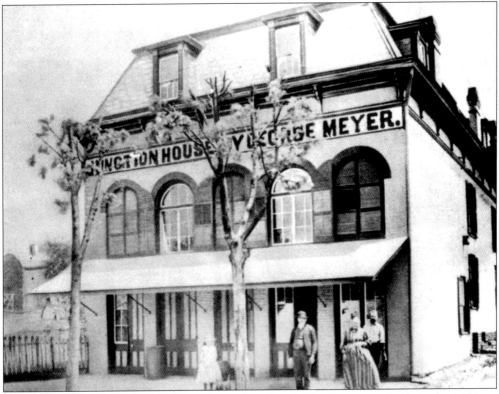

It is thought that the Junction House, located on South Elm Street, was built in the 1850s to accommodate workers who were laying the tracks for the Junction Railroad. In 1868, it was bought by George Meyer, a German immigrant. Meyer remodeled the Junction House and operated it for nearly 40 years as a tavern. In addition to serving alcoholic beverages, the Junction House provided overnight accommodations and served meals.

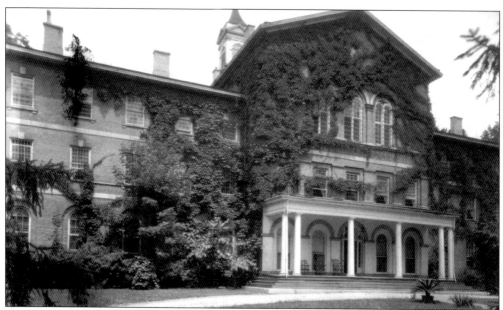

In 1882, the Oxford Retreat Company bought the campus of the Oxford Female College located northeast of the village. The Retreat was a sanitarium for people who suffered from mental illness, and the bars on the windows were to prevent patients from trying to escape. Three generations of the Cook family served as doctors at the Retreat before the building was sold to Miami University in 1925.

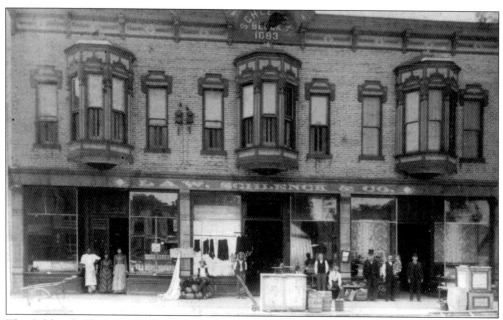

The Schlenck Block was built in 1883 just three years after Oxford's population reached 1,743. It was named for its owner, Moritz Schlenck, an immigrant from Bavaria. The Schlencks, along with their daughter's husband Thomas Law, an immigrant from England, sold groceries, dry goods, and shoes. Later a grandson, Charles Zwick, ran a fabric store here while Beasley's Bakery occupied the corner shop from the 1940s to the 1980s.

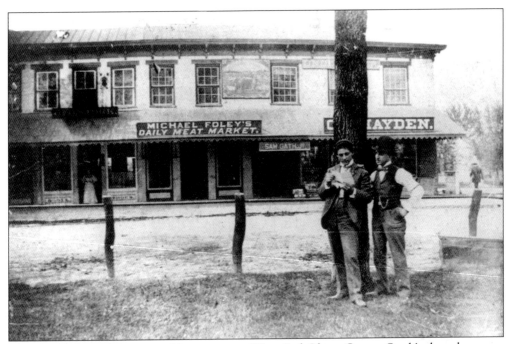

This 1880s photo shows several businesses on West Park Place: George Stork's shoe shop, Michael Foley's meat market, Sam Gath's undertaking establishment (on the second floor), and Charles Hayden's grocery store. Oxford continued to attract immigrants from northern Europe; Foley was from Ireland, and Gath was from England.

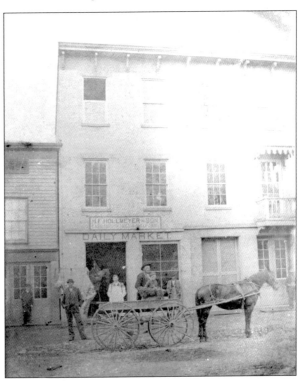

During the 1880s, Henry Hollmeyer operated a butcher shop in this building at 17 East High Street. (Like other German immigrants to Oxford, Hollmeyer had served in the Union Army during the Civil War.) In earlier years, the building had been occupied by Enoch Haskell's hat–making business. The building burned in 1996, and later the Minnis Building was constructed on the site.

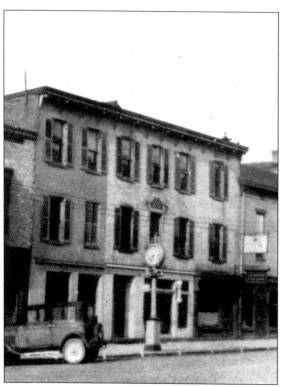

The working clock that stood at the curb easily identified Frank Schweeting's Jewelry Store at 17 East High Street. It served as an advertisement for the German immigrant's jewelry and watch repair business. In later years, the clock was moved to the north side of the street, and in 1979, the City took over responsibility for its care and maintenance.

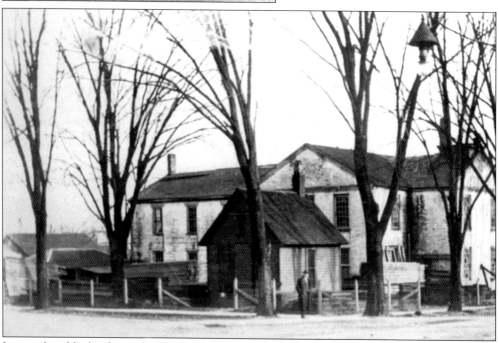

Just a few blocks from the High Street commercial district was the Lloyd and Hewitt lumberyard and planing mill. Located at the southeast corner of West Collins and South Beech Streets, the building had served as the Oxford School for over 30 years before Lloyd and Hewitt purchased it in 1887.

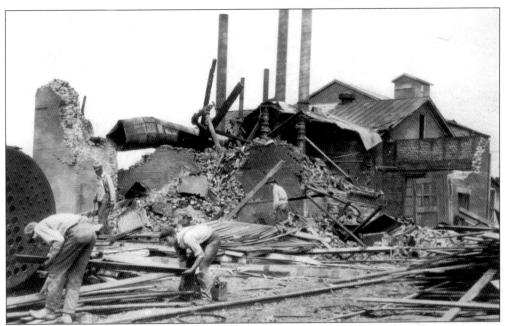

In 1889, one year before Oxford's population reached 1,922, a publicly owned electric light plant was constructed. (It is shown here as it looked after storm damage 35 years later.) This generating station was built just southwest of the intersection of West Spring Street and South College Avenue and was said to be the first alternating current system west of the Alleghenies.

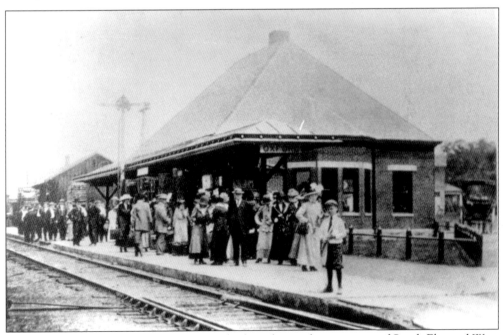

In 1895, a new, red brick train station was built at the northwest corner of South Elm and West Spring Streets. (The earlier frame building to the north was converted to use as a freight depot.) Many travelers, including college students, used the facility until passenger service was discontinued in 1950. The depot was razed in 1994.

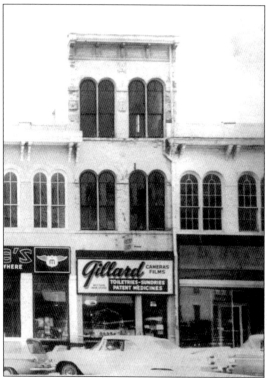

Gillard Drug Store, which opened in 1862, was established by English immigrant William Gillard. For most of its 98 years, the business was located in this three-story building at 27 West High Street. The pharmacy occupied the lower floors while Delta Kappa Epsilon fraternity met on the third floor. The letters D, K, and E were visible on the building until it was razed in 1962.

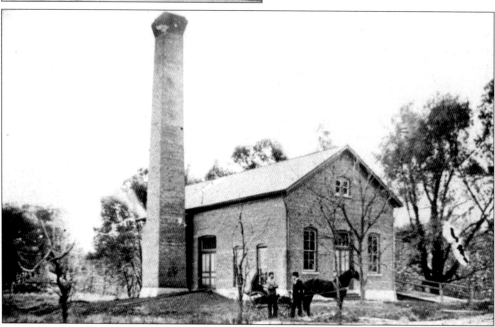

By 1896, Oxford had a water–pumping station just outside of town on the east bank of the Four Mile Creek. Known as the Waterworks, the red brick structure on Bonham Road housed steam-driven pumps that moved water from the wells in the creek valley to the village residents. Living quarters for a superintendent were added to the east side in 1932, and the building was razed in 2000.

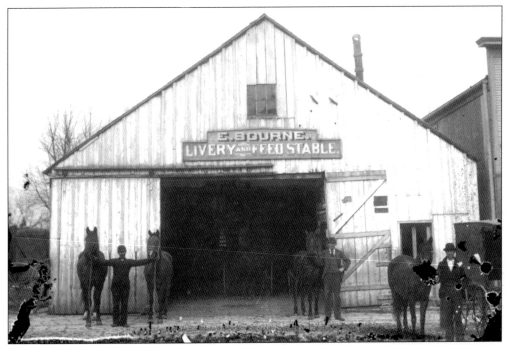

Ezra Bourne's Livery and Feed Stable is shown here as it looked about 1897. Located at the northeast corner of West High and North Beech Streets, it was one of several livery stables in Oxford. Within a few years, Bourne replaced this stable with a larger structure when he expanded his business.

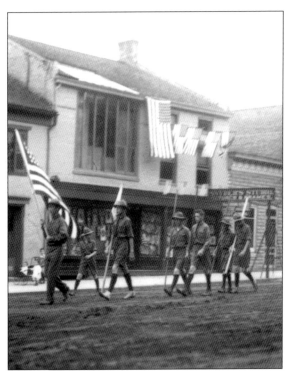

Frank R. Snyder came to Oxford in the 1890s and established his photographer's studio in this building at 37 East High Street. He later expanded his business by selling art supplies and stationery, and today the family-owned enterprise is Oxford's oldest business.

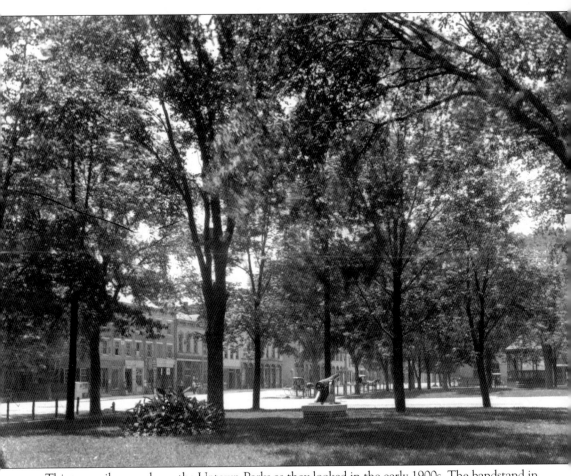

This tranquil scene shows the Uptown Parks as they looked in the early 1900s. The bandstand in the West Park (visible at right) was built in 1874 and remained until 1936. The cannon (at center) was placed in the East Park in 1885 by the Civil War veterans group, the Grand Army of the Republic (GAR). After the Market House was removed from between the parks in the 1870s, the names East Park and West Park developed. Prior to that time, the entire area had been called the Public Square. Another change was the removal of the fences that had surrounded the parks in order to protect the green space from poultry and hogs on their way to market. Once these animals began to be shipped by train, wandering livestock was no longer a concern. Hitching rails remained for several more years until automobiles replaced horse-drawn vehicles.

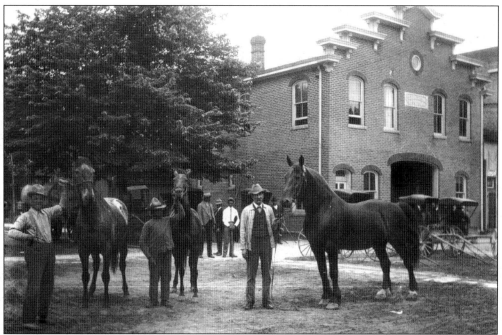

In 1900, Ezra Bourne erected this two-story brick sales barn at 38 West High Street. Bourne was known as an expert horse dealer, and his business drew buyers from great distances. The new structure included an interior ramp that allowed horses to be kept on the second floor. Bourne's son Bert assisted his father in the business.

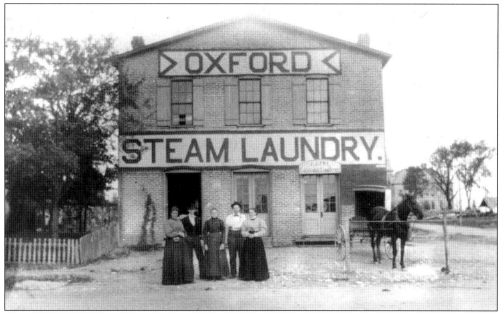

By 1900, the Village of Oxford had a population of 2,009, and more businesses were being established beyond the High Street commercial district. This laundry was located on the northeast corner of South Elm and West Spring Streets. Before the end of the century, the building was converted to use by the Oxford Fire Department.

This photograph of the East Park in winter was probably taken early in the 1900s. Photographer Frank R. Snyder captured the scene by standing across High Street from the southeast corner of the park. The cannon is visible at the center, the snow-covered drinking fountain and watering trough can be seen at the left along Main Street, and hitching rails are still in evidence

on all four sides of the park. The canopy of trees is the result of efforts of George W. Keely, an Oxford dentist. He encouraged residents to plant trees to replace those cleared by the early settlers. For this reason Keely became known as the "Father of Oxford Trees."

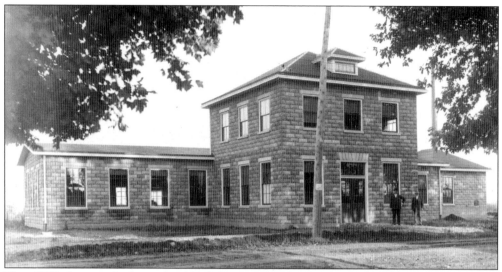

This 1905 photograph shows the Clock Factory shortly after it was built in the 500 block of South College Avenue. Although the concrete block and stone building has stood for almost a century, the original business that occupied it was short-lived. All of the investors' money disappeared along with the company's promoter. Shortly after the Clock Factory failed, Reeves' Specialty Company occupied the site, and it, too, was notably unsuccessful.

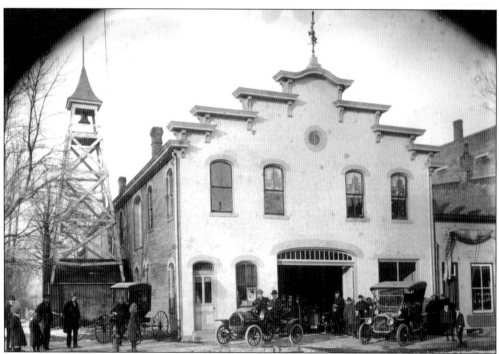

In 1906, the Oxford Hardware Company bought the Bourne building at 38 West High Street. The acquisition of this property allowed the owners to expand their implement line to include automobiles. Other commercial enterprises occupied the site after the hardware store closed in 1984. (The bell in the tower at the left was used to summon volunteer firemen from the West End of town.)

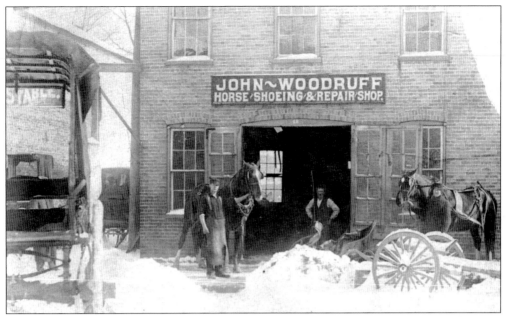

John Woodruff's blacksmith's shop at 48 East Park Place is shown here as it looked in the early 1900s. Horseshoeing was one of the earliest businesses to be established in the village, and the last blacksmith's shop was still in operation in the 1930s.

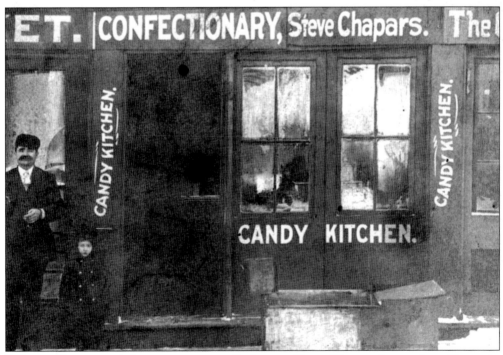

Stilianos Tsapatsaris (whose name eventually became Steve Chappars) came from Greece in 1903. He first supported his family by selling peanuts from a cart, but by 1909, when this photograph was taken, he was the proprietor of a candy store on High Street. Later he owned a restaurant called the College Inn on the southwest corner of High and Poplar Streets.

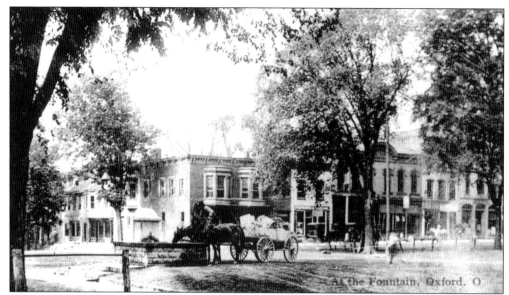

This view of the southwest corner of High and Main Streets was taken from the East Park not long after the village population reached 2,017 in 1910. After a fire destroyed its third floor, the former Cone House (on the corner) was extensively remodeled as a two-story building facing High Street. A combination watering trough and drinking fountain for public use can be seen in the foreground.

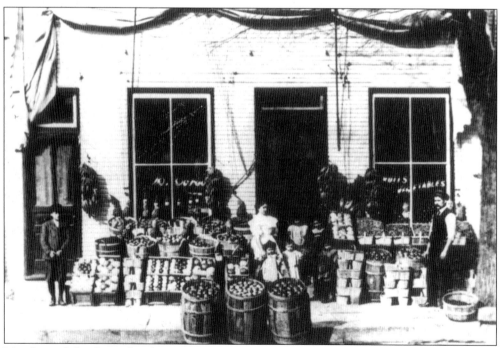

Members of the Corso family, immigrants from Sicily, are shown here in front of their fruit market at 36 West High Street. In 1912, after seven years at this location, they moved to 109 West High Street, where they operated a grocery store for another 64 years. (The building pictured here was razed in 1949 to make room for the office of a utility company.)

This theatre was one of several movie houses in Oxford. Silent films were first shown in a room on West Park Place and later in a theatre on West High Street. The theatre pictured here opened at 10 North Beech Street in 1911. It was first called the New Oxford Theatre, then the Oxford Theatre, and then the Talawanda for about 40 years before becoming the Princess in the 1980s.

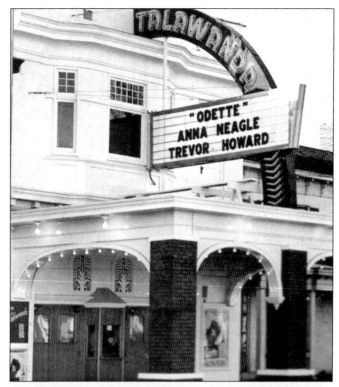

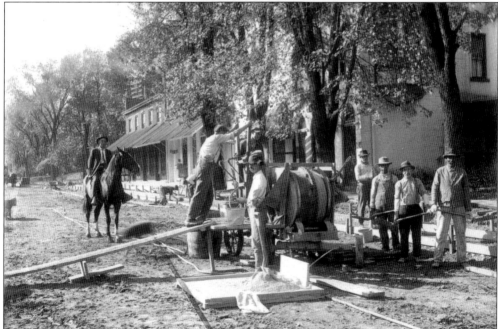

Taken in 1916, this photograph shows workers engaged in paving East High Street with bricks. Prior to this time, the dirt street was muddy in wet weather and dusty in dry weather despite routine applications of oil during the summer. After High Street was paved with bricks, several other streets received the same treatment, and Miami University contributed money to the project.

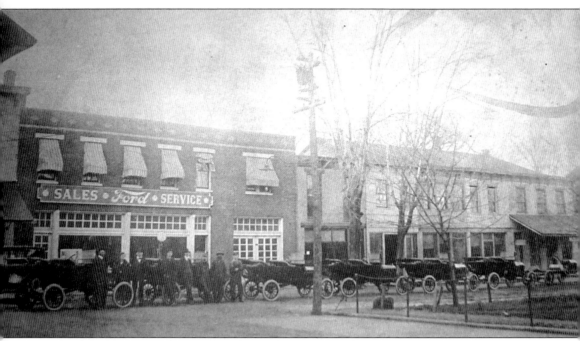

These buildings on the north side of the West Park housed a variety of commercial establishments when this photograph was taken in 1919. Just left of center was a car dealership started by Arthur Stork in 1917, and car dealerships under different management remained in this location for over 50 years. During the late 1920s and early 1930s, the buildings to the right were occupied by businesses that were run by African Americans. These included a pool hall, a lunchroom managed by Ed Woods, and a barbershop operated by John Warren. A grocery store was also located in this block before the buildings at the right were razed to make room for a gasoline station. An insurance company remodeled the buildings at the left in 1971, and a bank replaced the gas station at the end of the twentieth century.

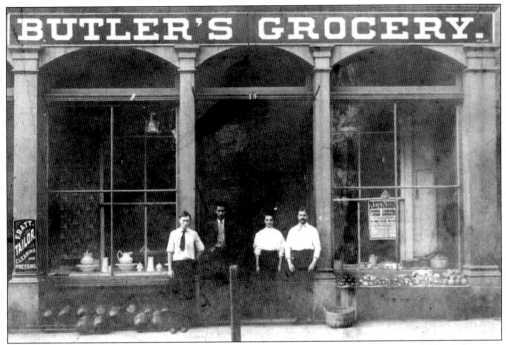

This West High Street grocery owned and operated by John Butler was typical of those in uptown Oxford in the nineteenth and early twentieth centuries. Small, independently owned groceries such as this one co-existed in Oxford well into the second half of the twentieth century. These "mom and pop" establishments disappeared when more and more customers were drawn to supermarkets.

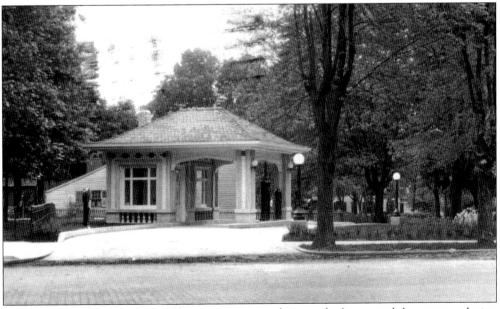

By 1920, when H.S. Coulter's filling station was photographed, automobiles were replacing horse-drawn conveyances in Oxford. This business was located on the southeast corner of West High Street and South College Avenue, and the site is still occupied by a gasoline station today.

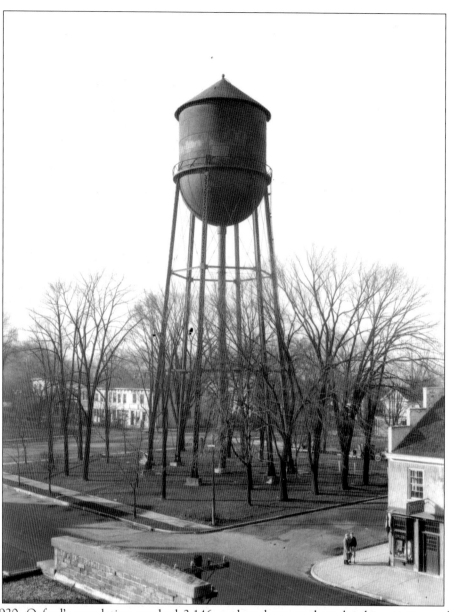

In 1920, Oxford's population reached 2,146, and students at three local institutions added another 1,500 people. The Village needed to improve its water-supply system, and the result was the construction of a water tower (342 feet tall) in the East Park in 1922. The location was selected for two reasons—elevation and ownership. A gravity-flow system required a site with an elevation high enough to maintain adequate pressure, and the uptown area met this requirement. Because the Village already owned the park, it could avoid spending more money on additional land. Residents initially complained that the tower spoiled the look of the park, but by mid-century, the water tower was referred to as a landmark. In the early years, it was painted black, but for most of its 76 years, the tower was painted silver and could be seen on the horizon from miles away. Travelers knew they were nearing Oxford when the water tower appeared on the skyline. It was taken offline in 1993, and despite preservationists' efforts to save it, the tower was dismantled in 1998.

The Oxford Post Office at 40 East Park Place was built in 1924. This was only the second building in Oxford that was constructed specifically for use as a post office. (The first one was built at 12 South Beech Street in 1914.) Prior to that time, the appointed postmaster simply operated from his own place of business, which was usually somewhere on High Street.

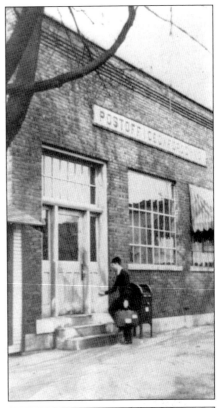

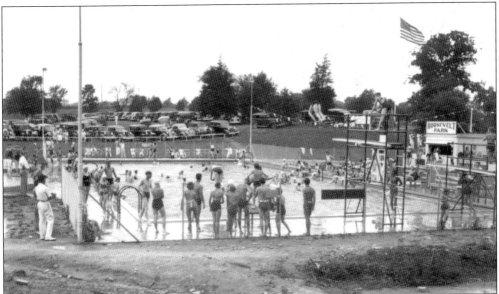

In 1930, Oxford's population reached 2,588, and four years later the Village constructed a swimming pool on the north side of Contreras Road. Because the land was acquired from the Oxford Golf Club (forerunner of the local country club), village officials agreed to enforce the club's "whites only" policy. It was not until 1950, after the local NAACP branch took legal action, that African Americans could use the public pool.

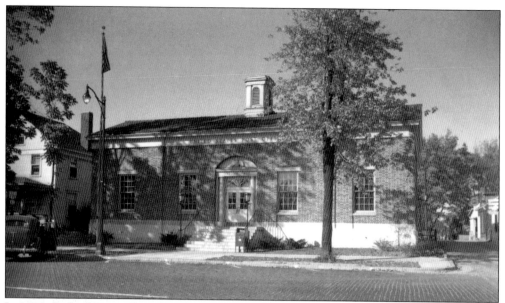

In 1938, Oxford's post office changed locations once again. Federal funds were used to construct this new building at 118 West High Street. It was the third building erected exclusively for use as the local post office, and it served that purpose for 50 years. By the end of the century, the building was being used as the Oxford Courthouse.

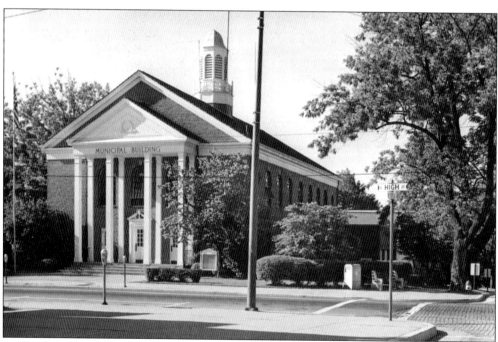

By the 1930s, the village government had outgrown the old Town Hall. Under the leadership of Mayor Verlin Pulley, Oxford succeeded in acquiring federal aid and in 1939 completed construction of the new Municipal Building. Located on the site of the old Town Hall, it is seen here in a photo by George Hoxie. The rear portion of the building was occupied by the fire department until 1983.

In 1939, an incinerator began operating on the west side of Morning Sun Road just north of Oxford. This village-owned utility was built to burn trash collected from residences and businesses while the town dump south of the village continued to receive non-combustible refuse. By the early 1950s, the incinerator was abandoned, and the dump was converted to a sanitary landfill that was used for another 40 years.

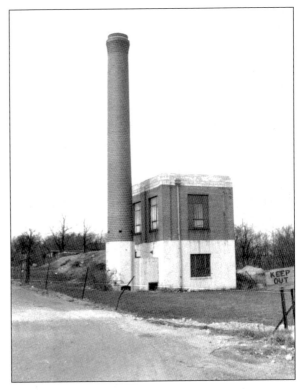

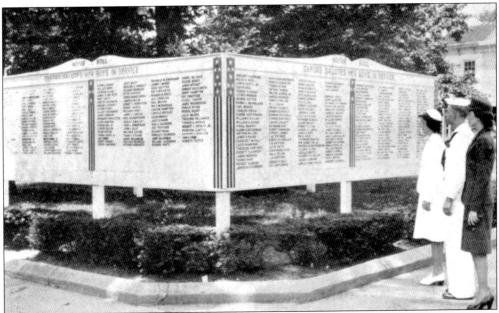

The year before the United States entered World War II, Oxford's population was 2,756, and Miami students added another 3,974. When thousands of military men and women came for training, a USO club opened Uptown, and Oxford businesses prospered from government contracts for haircuts, laundry services, and shoe repair. Oxford's own service personnel were named on an Honor Roll in the West Park, shown here in a Gilson Wright photo.

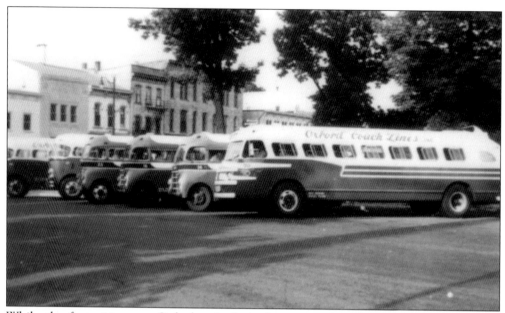

While the first visitors to Oxford arrived on foot or on horseback, later ones came by stagecoach, train, automobile, and bus. These buses at the station on East Park Place, photographed by Gilson Wright in 1948, were just some of many that ran between Oxford and nearby cities for almost half a century. Connecting service in larger cities allowed riders to travel all over the country.

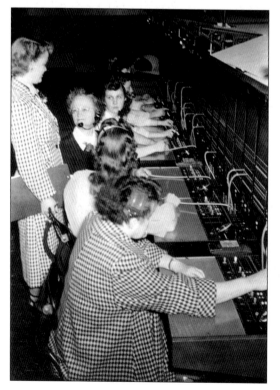

Operators at the local telephone company are shown here soon after Oxford's population reached 3,110 in 1950 with Miami University and Western College students adding another 5,627. Although a few individuals and businesses had strung their own telephone wires in the 1880s, a company was not organized to provide telephone service until 1902, and direct dialing was not implemented for another 50 years after that.

Five

VILLAGE SCHOOLS

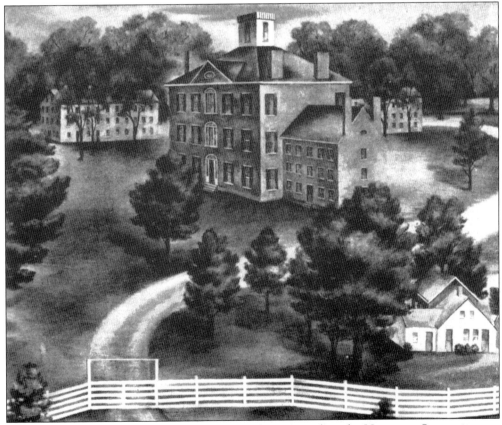

The first schoolhouse in Oxford was erected in 1811. Located on the University Square, it was a one-story building constructed of hewn logs. It is shown here in a later picture as part of the building in the foreground. Other early schools included a log building on the corner of Beech and Collins Streets in 1815 and a brick one near the northwest corner of Poplar and Collins by 1825.

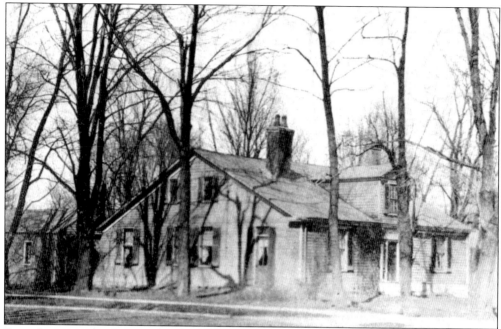

Several young women ran private schools for girls from the 1820s to the 1860s. Julia Rogers used a front room in her parents' house on East High Street for this purpose. (In later years this house became Miami University's Simpson Guest House.) A. Smith, Bethania Crocker, Abigail Clark, and three sisters in the North family ran other early schools.

Oxford's first public school for African-American children was established soon after the State of Ohio mandated it in 1853. Shown here is the one-story brick building on the east side of the first block of South Beech Street. Prior to 1853, a "mission school" for African Americans had been provided by local Presbyterians, but its location is not known.

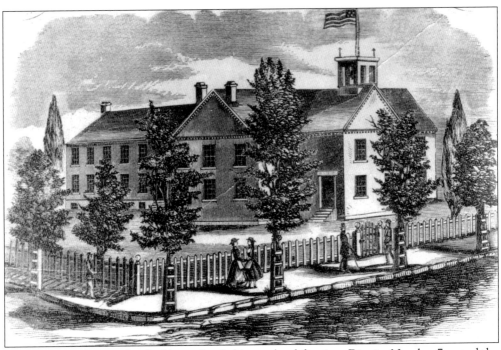

In 1821, Oxford Township had been divided into school districts. District Number 7 served the Village of Oxford and students from two neighboring districts on the village side of Four Mile Creek. For this reason the school built in 1853 was called Union School. Located on the southeast corner of South Beech and West Collins Streets, it admitted only white children. In 1874, the first high school classes were held.

A few years after white children began attending the Union School on South Beech Street, African-American children started attending a separate school on North Beech Street. This photograph taken about 1880 shows the students with their teacher John East in front of their two-room, one-story building. It was located on the west side of North Beech Street between West Withrow and West Vine Streets.

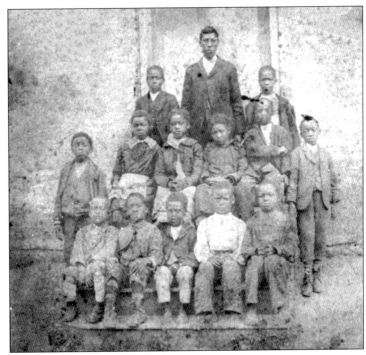

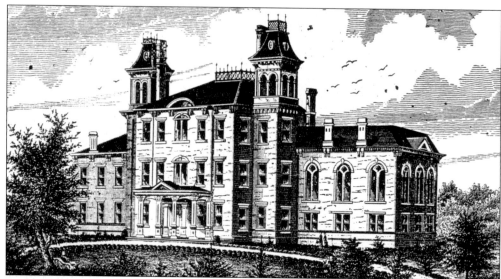

During the 12 years that Miami University was closed, its buildings were leased to the Miami Classical and Scientific Training School. Students took classes in Latin, Greek, English, mathematics, science, music, modern languages, and telegraphy. Interestingly, this building pictured on the school's catalog and stationery would not actually have a second tower and east wing until more than a decade after Miami University reopened in 1885.

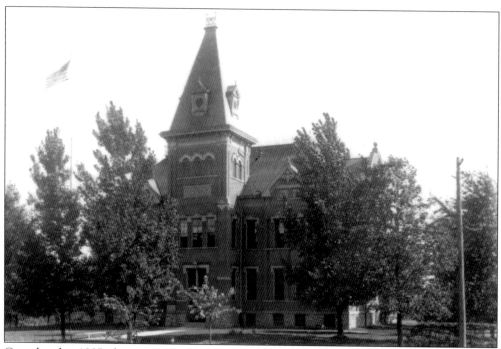

Completed in 1887, the new Oxford Public School was located on the southeast corner of West Spring Street and South College Avenue. When the school board refused to admit African American students, a parent named Perry Gibson sued. The case, which was eventually decided in the Ohio Supreme Court, resulted in the racial desegregation of Oxford's public schools. (This building was razed in 1951.)

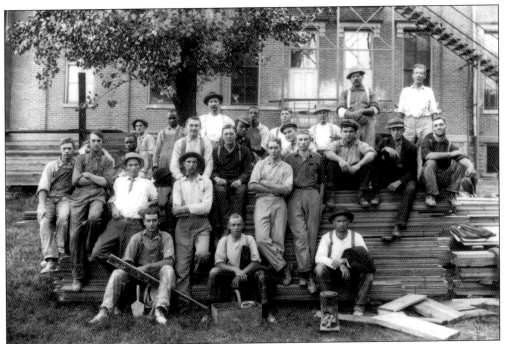

These workers are shown outside the Oxford Public School on West Spring Street. They were probably employed to build the auditorium as a rear addition to the school building about 1910. The school served all 12 grades from the time it opened in 1887 until high school students moved to a new building in 1929.

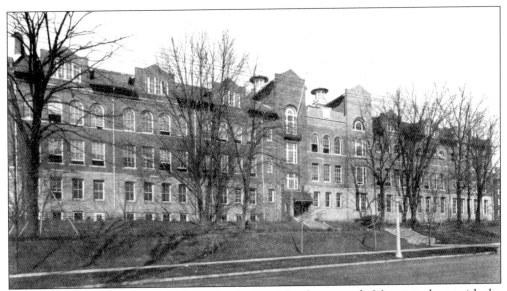

In 1910, Miami University established McGuffey School to provide Miami students with the opportunity to observe and practice teaching. This laboratory school, located in the university building on the northeast corner of Spring Street and Campus Avenue, was open to white students in elementary and later secondary grades. The high school portion closed in 1956, and the lower grades closed in 1969. (African American students were admitted in 1966.)

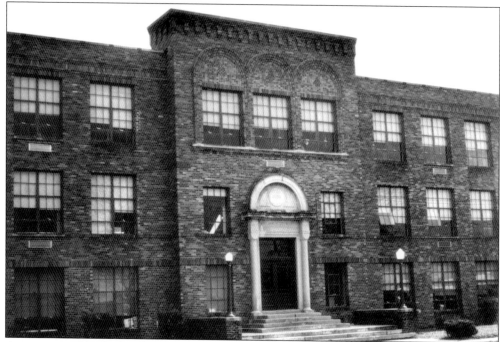

A separate public high school building was constructed in 1929 and named for William H. Stewart, who had served as school superintendent for many years. This high school was located on South College Avenue just behind the older Oxford Public School building. Stewart School later served as a junior high and then as one of several elementary schools in the larger, consolidated Talawanda School District before closing in 2003.

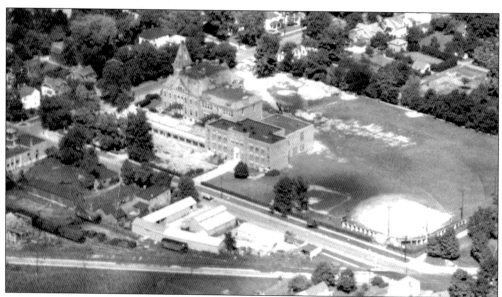

This 1951 aerial view shows the old Oxford Public School on West Spring Street with Stewart High School to the right facing South College Avenue. The first floor of an addition to the high school can be seen at the left. After its completion, the three-story north wing housed the lower grades, so that all ages were under one roof again. (The old school was razed soon after.)

Six

EARLY CHURCHES

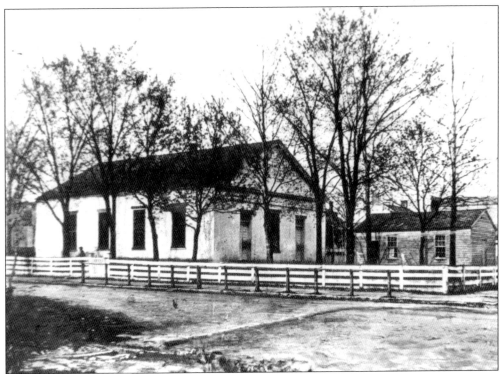

Methodist preachers on horseback visited the Oxford area as early as 1805, and by 1813, Methodists were worshipping in a log building on the corner of South Beech and West Collins Streets. By 1820, they had finished constructing this one-story church on the southwest corner of East Church and North Poplar Streets. The building was enlarged in 1839 and razed in 1872.

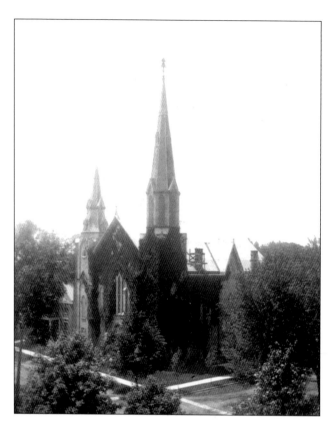

The construction of a new, larger Methodist church began in 1872. The lower level was in use in 1873, the upper level was occupied in 1875, and the two spires were completed in 1885. The new church was located on the same lot as the earlier building but faced Poplar Street instead of Church Street. (A south wing was added in 1969.)

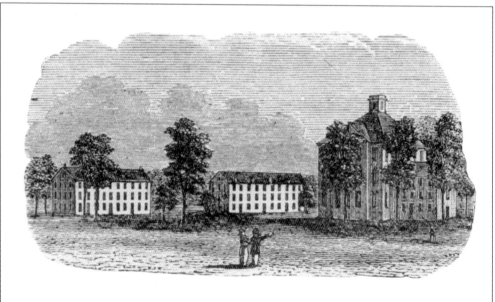

Presbyterians organized in 1818 and first held services in the homes of members. Beginning in 1825, they worshipped in the Miami University chapel with the university president serving as the minister. The university chapel was a room in the main campus building seen here at the right in a drawing by Henry Howe.

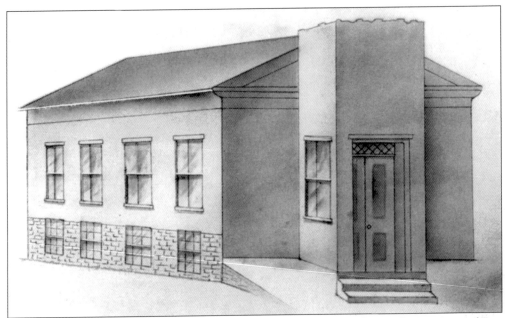

The First Presbyterian Church, completed in 1833, was located on the northeast corner of East Church Street and North Campus Avenue. This drawing by Adelaide Rogers shows the church after the tower fell in a storm. By 1850, the Third Presbyterian Church shared the building and minister of the First Church. In 1863, the First Church dissolved, and in 1865, the remaining Third Church assumed the name First Church.

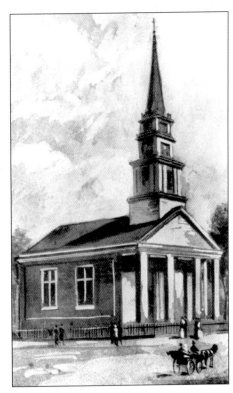

In 1841, a group of Presbyterians left the First Church to form the Second Presbyterian Church of Oxford. In less than two years, they had erected this building on the northeast corner of East Church and North Main Streets. The church was enlarged with an addition at the rear in 1852.

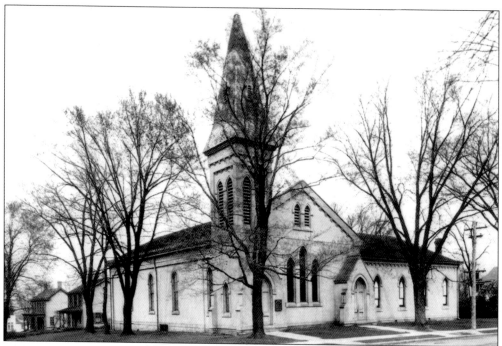

In 1869, the First and Second Presbyterian Churches reunited. The combined congregations decided to keep the building of the Second Church (on the northeast corner of Church and Main) and call themselves the Presbyterian Church of Oxford. Their building is shown here after it was enlarged with additions to the south in 1875 and to the east in 1887. The church was razed in the mid-1920s.

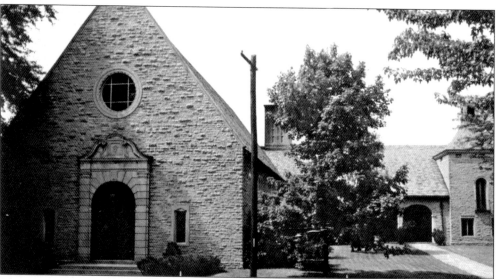

The congregation that resulted from the reuniting of the First, Second, and Third Presbyterian churches constructed a larger building on the northeast corner of Church and Main. This new church was dedicated in 1927 and named the Memorial Presbyterian Church because it was erected with funds given in memory of the donor's husband and daughter. The name was changed to Oxford Presbyterian Church in 1983.

Organized in 1834, the Associate Reformed Church had by 1839 completed this building on the northeast corner of East Church and North Poplar Streets. (The congregation shared the building with the Oxford Theological Seminary for almost two decades.) In 1858, the church name was changed to United Presbyterian, and after the 1966 merger with the Memorial Presbyterian Church, the building was used for social and charitable functions.

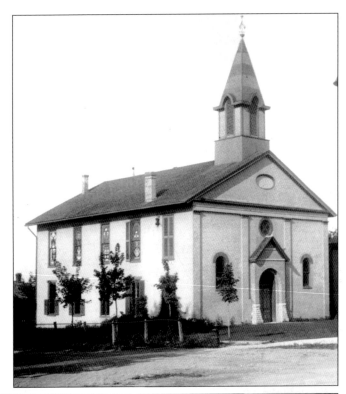

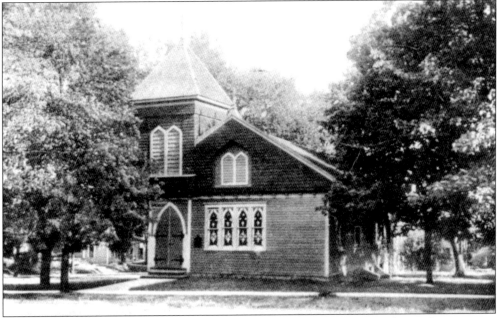

After organizing in the 1830s, the Universalists built a frame church near the northwest corner of East Walnut Street and South Campus Avenue in 1839. Later in the century, they moved this building to the southwest corner of East Walnut and South Poplar Streets where they continued to worship until they sold the building in 1891. (It was next used as a Temperance Hall and even later as an Episcopal Church.)

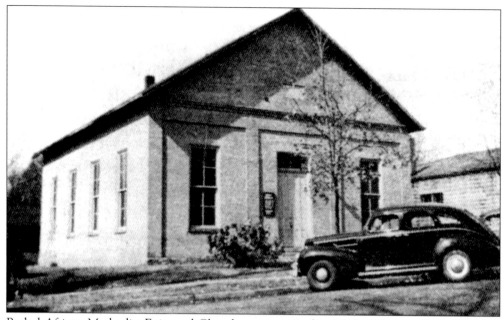

Bethel African Methodist Episcopal Church was organized in 1842, making it Oxford's oldest African American church. Members worshipped in a log house until 1857 when this South Beech Street building was purchased. The AME congregation remodeled the church in 1896 and added a rear annex in 1955. (The building had been erected in 1845 for the white congregation of a short-lived Christian church.)

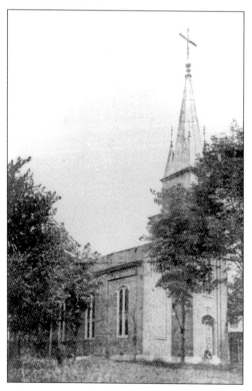

Oxford Catholics established St. Mary Church in 1853 and for 15 years worshipped in a former schoolhouse on the northwest corner of Collins and Poplar Streets. In 1868, this church was completed on the northwest corner of West Withrow and North Locust Streets. The property also included a parish house and Mt. Olivet Cemetery before the church building was destroyed by fire in 1917.

When members of St. Mary Church made plans to rebuild after the fire of 1917, they decided to relocate closer to the center of town. Dedicated in 1921, their new church on East High Street between Campus Avenue and Poplar Street was only a short distance from Miami University's campus. A west wing was completed in 1942 to house a rectory and meeting rooms.

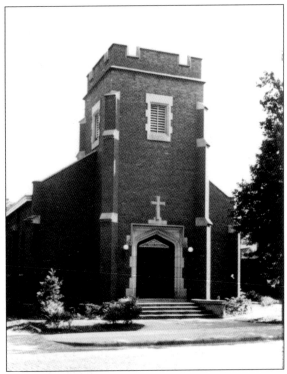

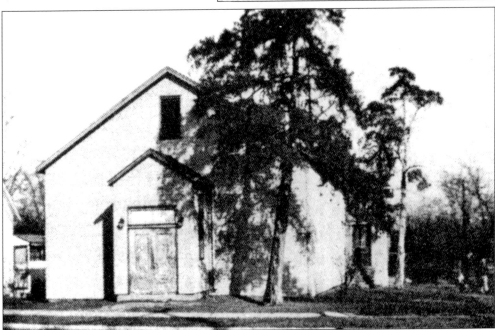

Oxford's Christian African Church, the first of its denomination in Ohio, was established in 1863. Members met in homes and in a schoolhouse before buying a small building on the northwest corner of West Withrow and North Elm Streets. Shown here is a larger church that replaced the earlier one in 1881. Later known as Elm Street Christian Church, this building burned in1952 and was rebuilt by 1957.

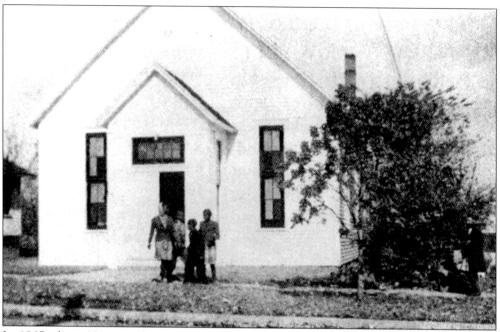

In 1865, about 20 years after an earlier Baptist Church ceased to exist, the Baptist African Church was organized. After worshipping in the former schoolhouse previously used by the Catholics, the congregation built this church at 14 East Vine Street in the 1890s. Later known as the Colored People's Baptist Church and finally as First Baptist Church, the building was destroyed by fire in 1947 and rebuilt in 1950.

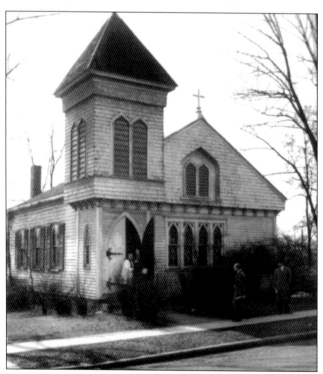

Oxford's Episcopalians organized in 1894. They first met in a room in Old Main on Miami's campus and later used the Town Hall. In 1899, they purchased this building (originally a Universalist Church and later a Temperance Hall) on the southwest corner of East Walnut and South Poplars Streets. This first Holy Trinity Episcopal Church was razed in 1949 so that a larger one could be built on the site.

Seven

LEISURE ACTIVITIES

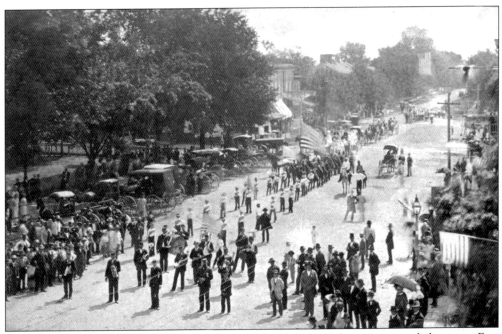

This Fourth of July parade of 1879 was photographed by J.C. Toler as it proceeded west on East High Street. Oxonians also turned out to watch parades on Armistice Day, George Washington's Birthday, and Memorial Day. Miami University Homecoming parades also drew large crowds.

Fishing was a popular pastime for all ages. This 1888 photograph by William McCord was taken along a nearby creek known both as the Tallawanda and as the Four Mile. The first name was thought to be a Shawnee term for cloudy water. The second came from the army of General Arthur St. Clair as it marched north in 1791, naming each creek for its distance from Fort Hamilton.

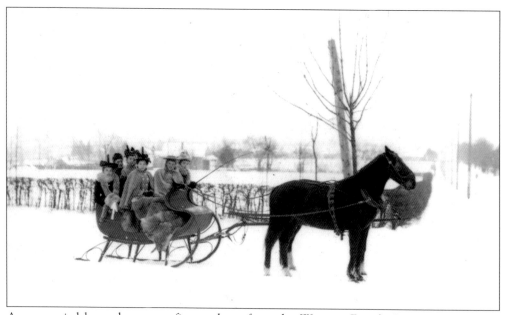

Accompanied by a chaperone, five students from the Western Female Seminary enjoyed a sleigh ride during the winter of 1893. Frank R. Snyder took the photograph as he stood on South College Avenue near the intersection of West Spring Street.

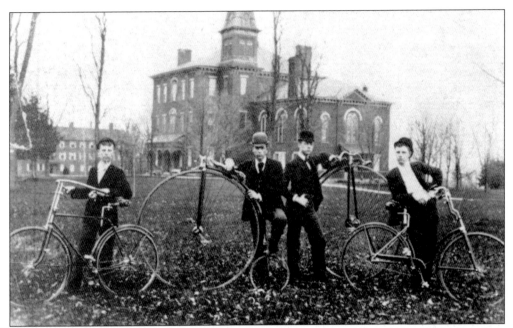

Although bicycles were ridden in Oxford in the 1880s, it was not until the 1890s that their popularity soared. Students at the Western had a bicycle track on their campus by 1894, and Oxford College women formed their own bicycle club. The Miami students shown here may have been among those who bicycled to College Corner, Morning Sun, Hamilton, and even as far as Liberty, Indiana.

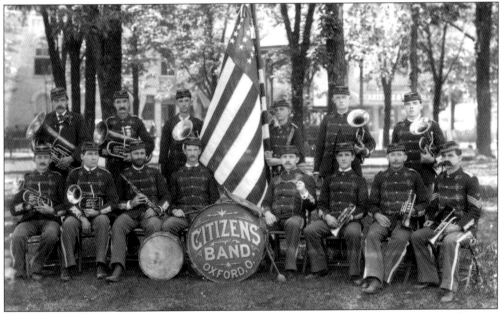

The Citizens Band, shown here in the West Park in 1908, was one of several instrumental groups that entertained Oxford audiences. Newton's Cornet band was popular before and after the Civil War, and Miami University organized a band in 1897. For eight years beginning in 1905, African Americans had their own 15-piece band that played in Oxford and neighboring towns.

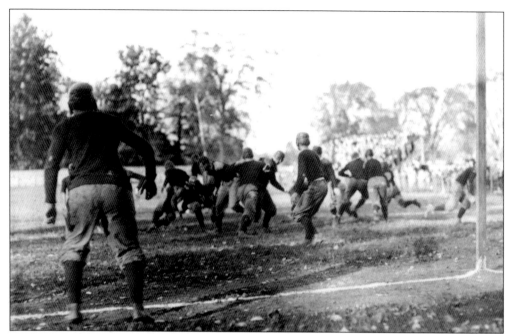

By the time this 1910 photograph was taken of a football game between Miami University and DePauw University, the sport had been played in Oxford for over two decades with local fans in attendance at all the home games. The first collegiate football game in Ohio was played in Oxford in 1888 when Miami and the nearby University of Cincinnati began their long-standing rivalry with a scoreless game.

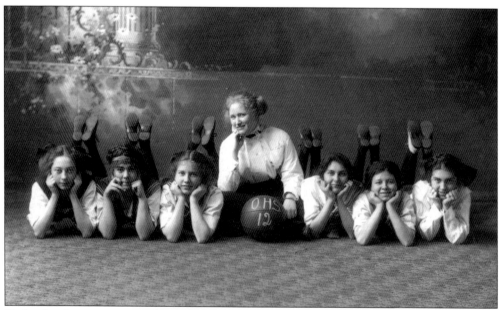

High school sports were not limited to boys' teams. The subjects of this picture were members of the Oxford High School girls' basketball team of 1912, whose games were played in Miami's gymnasium. Admission to a home game was 10¢ for children younger than high school and 15¢ for all others.

The Daisy Field east of Oxford was in full bloom when this summer scene was photographed. Although on private property, the field became a public attraction each year as people of all ages walked to the field to gather huge bouquets of flowers. College students wrote home about it, and visitors came to view the sight. Photographer Frank R. Snyder sold postcards made from his pictures of the field.

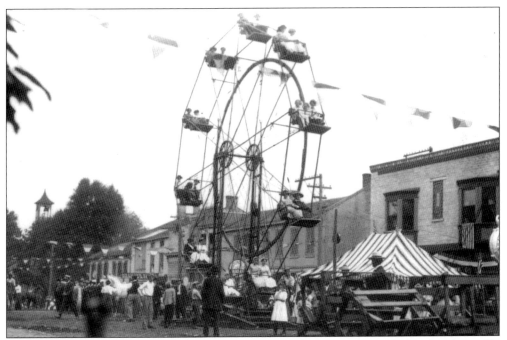

A Ferris wheel was only part of the fun at the 1913 Oxford Street Fair. With vehicular traffic blocked from High Street, tents were set up for the display of fruits, vegetables, grain, livestock, baked goods, and sewing projects. Oxford's annual fair drew exhibitors from all around the area, and substantial prizes were awarded to the best products in a variety of categories.

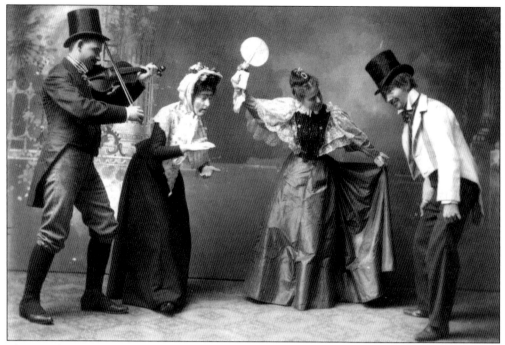

Theatrical productions were a popular form of entertainment in Oxford. Most of the three-story buildings on High Street had meeting halls on their top floors that could accommodate large groups for a variety of events. Oxford's "Opera House" occupied the third floor of the Davis Building (26–28 West High Street) for many years. Both traveling companies and local groups performed for Oxford audiences.

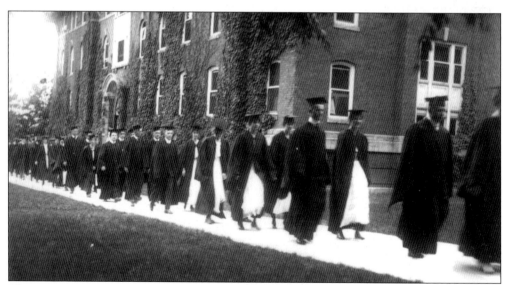

This 1916 commencement procession at Miami was one of three such events that took place in Oxford each spring. The local newspaper ran front-page announcements of the graduation ceremonies at the University and at the two women's colleges. These programs were considered cultural opportunities for the public, and many residents attended in order to be enlightened by the addresses given by graduating students, faculty members, and guest speakers.

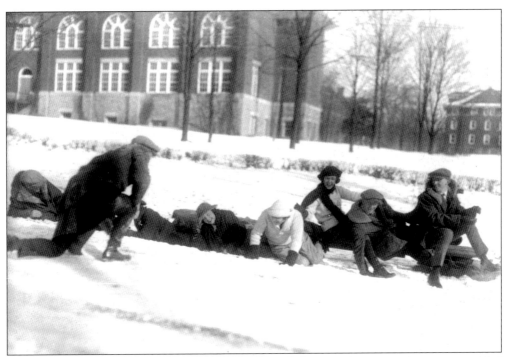

These college students enjoyed good sledding on South Campus Avenue as the street provided a slope steep enough for an exciting ride. Injuries were not uncommon, and at least one person (an Oxford College student) died as a result of a sledding accident.

Another activity that drew crowds of spectators was the Tug of War between Miami freshmen and sophomore men. The annual event was usually held along the Four Mile Creek, which was within easy walking distance of town. This 1921 photograph of the event was taken by Frank R. Snyder.

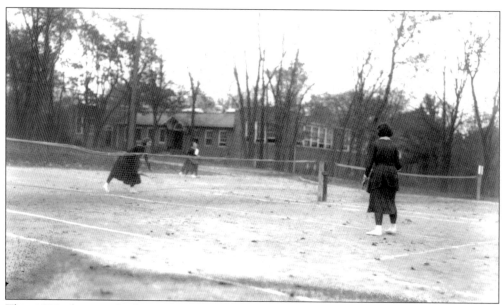

This 1923 photograph shows Miami students playing tennis on a court near the center of campus. Tennis came to Oxford in the early 1880s when it was still relatively new in the United States. It became a regular college sport at Miami in 1888, and additional courts were built in 1894. Sometime after that, Western College and Oxford College added tennis courts to their own campuses.

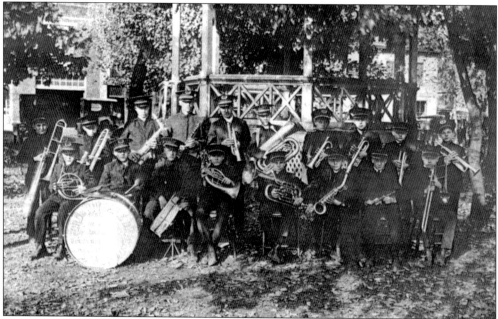

The Oxford Juvenile Band is shown here in the West Park in the late 1920s. The bandstand in the background was the scene of many musical performances. An unusual one took place in 1922 when African-American vocalists called the Twilight Trio sang at a Cincinnati radio station. The program was broadcast by loud speakers from the bandstand so that Oxonians could listen to their hometown singers on the air.

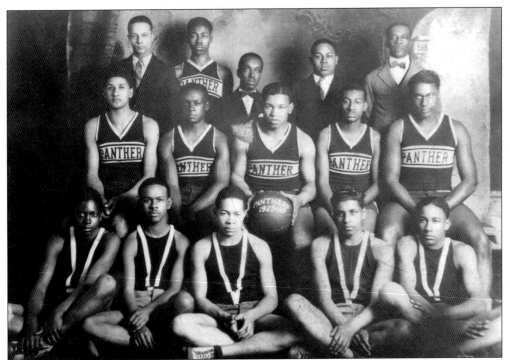

Because Oxford's school did not allow African Americans to play on its basketball team, parents provided funds for their sons to form a separate team. Calling themselves the Panthers, they played similar teams in Ohio, Indiana, and Kentucky beginning about 1919. Home games were played on the second floor of the Town Hall where local fans cheered the team that played some of the best basketball ever seen in Oxford.

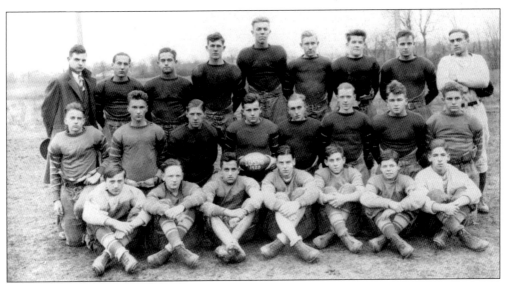

McGuffey High School's 1928 football team is shown here after a season of winning every game. Oxford sports fans were fortunate to be able to see football, basketball, baseball, and other athletic competitions at Miami University, Oxford High School, and McGuffey High School. Not many small towns could provide so many men's sporting events.

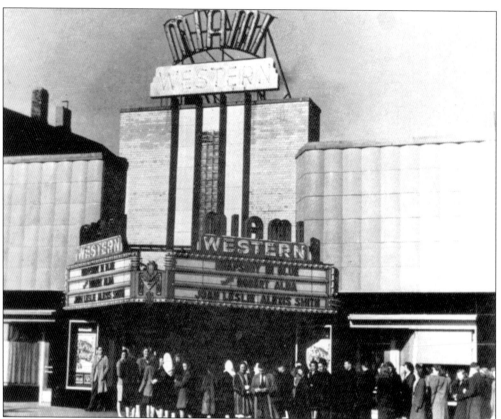

When the Miami Western Theatre opened in 1938, it was bigger than any of Oxford's earlier movie houses. With superior sound equipment, cushioned seats, and air conditioning, it was a popular entertainment destination. Two large murals could be seen the interior walls of the theatre—one depicted student life at Miami University, and the other showed the same at Western College for Women.

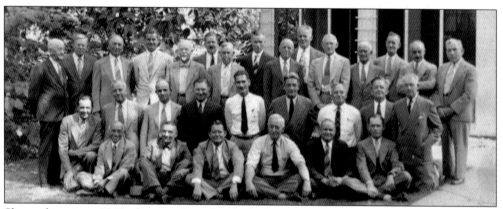

Shown here in a 1941 photograph is the Oxford Kiwanis Club, a service organization that sponsored the local Boy Scout troop. Kiwanis was just one of a number of groups that provided Oxonians with opportunities to gather for social, educational, and philanthropic purposes. Among others were farmers' clubs, a current events club, veterans' posts, a literary club, women's clubs, a garden club, Masonic lodges, and a music club.

Eight
MEMORABLE EVENTS

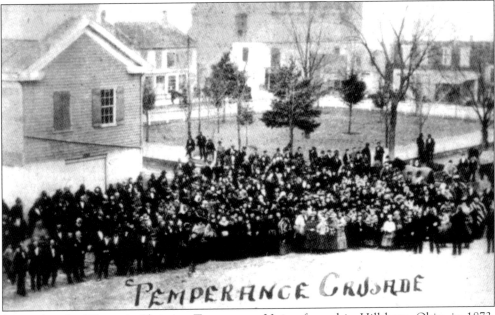

Soon after the Women's Christian Temperance Union formed in Hillsboro, Ohio, in 1873, Oxford reformers began working to rid their town of problems caused by alcohol. Women led prayer vigils outside saloons and asked the proprietors to close their businesses. Supporters signed pledges to abstain from alcoholic beverages, and most of Oxford's saloons did close, though not permanently, as a result of the crusade.

This natural gas well was drilled in 1887 on West Collins Street near the intersection of South Elm. Although pockets of gas were found, and crowds gathered to watch the flames that were produced, excitement waned along with the supply of gas. Photographer William McCord titled this picture "Great Expectations," but investors eventually suffered disappointment and financial loss when nothing came of the project.

Although Oxford was usually a law-abiding town, lynchings were attempted on three occasions. This illustration from the *Cincinnati Enquirer* shows the 1892 lynching of an African American in Oxford's East Park. (He had been accused of murdering a white woman.) Fifteen years earlier, a similar incident took place, and 11 years later a mob's efforts to hang a white man were thwarted by a minister and law enforcement officials.

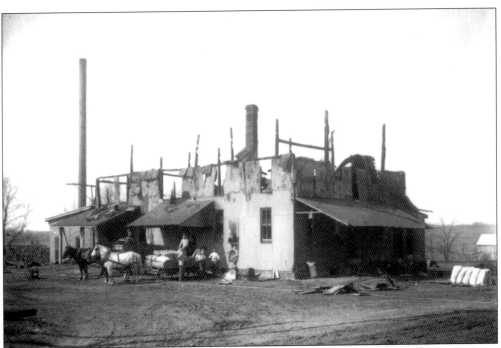

In April 1912, a fire caused extensive damage to this flour mill on West Spring Street between South College Avenue and South Elm Street. Throughout the nineteenth and twentieth centuries, fires in Oxford caused deaths, injuries, and property damage. Included in the losses were barns, houses, churches, dormitories, apartments, stores, and other businesses.

During the Flood of March 1913, the Four Mile Creek overflowed its banks, and water covered the entire valley. This view, taken from what would later be Shadowy Hills Drive, shows the Waterworks and the Bonham Road Bridge. Although the village water supply was interrupted, Oxford was fortunate to be spared the loss of life and damage to property that was suffered by the cities of Hamilton, Middletown, and Dayton.

Members of Oxford's Home Guard are shown here shortly after the United States entered World War I. Other Oxonians served overseas as ambulance drivers or as soldiers. Six Oxford men died, and the local American Legion Post was named Coulter for the first of these men to lose his life. After the War ended, the federal government gave the Post a naval cannon, which was mounted in the West Park.

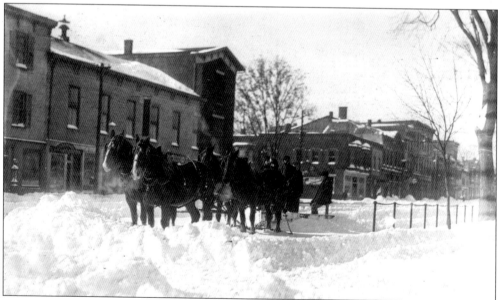

The men and horses shown here used a V-shaped wooden plow to clear the streets of snow after one particularly big storm. The blizzard of January 1918 closed schools and stranded a train between College Corner and Oxford. After the deep snow had been pushed aside, it had to remain on the street until warmer temperatures melted it.

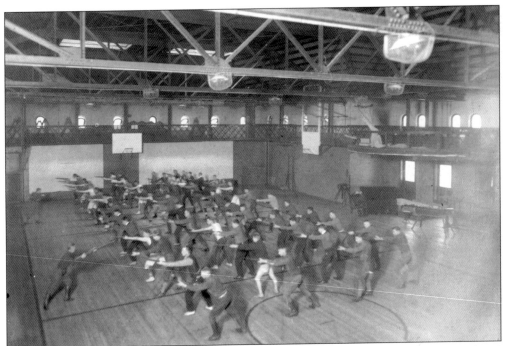

World War I brought changes to Miami as well as to Oxford. In the fall of 1918, a Students' Army Training Corps was established at the University. Four hundred Miami men divided into four companies marched to and from their classes and drilled on the campus. This photograph was taken in Herron Gymnasium as one group practiced close order drill.

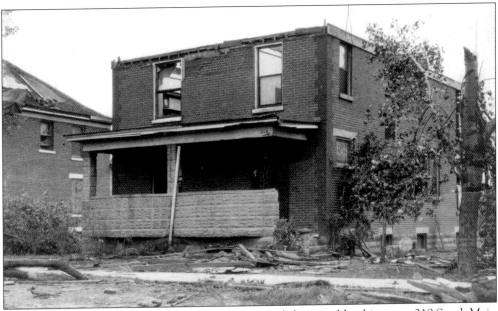

The tornado that ripped through Oxford in June 1924 left scenes like this one at 319 South Main Street. Although the roof of the Baer family's house was blown several blocks away, their baby was found uninjured in her crib on the second floor. The tornado traveled from west to east across the southern half of the Mile Square leaving a path of damage several hundred feet wide.

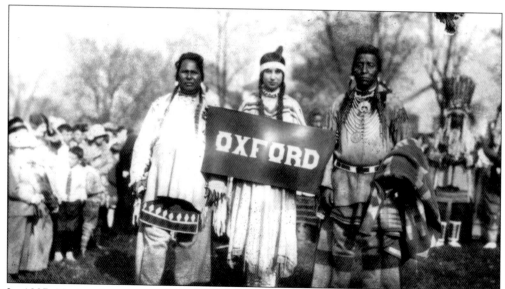

In 1927, Native Americans of the Blackfoot Tribe came to Oxford on the B&O Railroad's Centennial Train. At a ceremony on the campus of Oxford College for Women, the tribal chief, the village mayor, and the college president made speeches and exchanged gifts. The event attracted a crowd nearly as large as those at Miami football games.

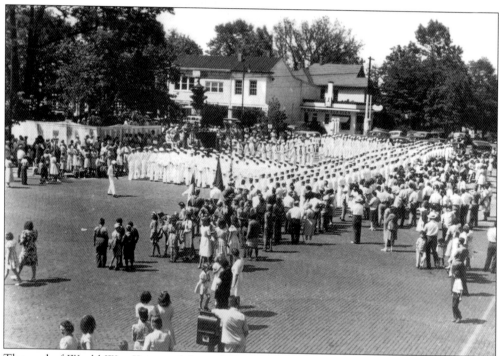

The end of World War II was celebrated with a parade and ceremony on August 14, 1945. The parade that proceeded west on High Street included Navy personnel and local groups. In this photograph by Gilson Wright, dignitaries can be seen addressing the crowd that congregated between the Uptown Parks with the Honor Boards serving as a backdrop behind the speaker's platform.

Nine

RURAL SCENES

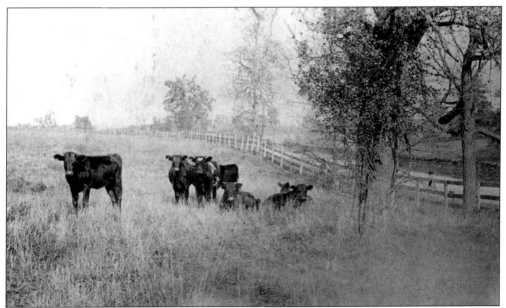

The countryside surrounding Oxford was mostly farmland in the late nineteenth century, and the sight of cattle grazing in a pasture was a common one. At the time this photograph was taken by William McCord in the 1880s, there were more than 14,000 head of cattle in Butler County.

This expansive view of the Four Mile Creek Valley was taken from the area now known as Shadowy Hills. William McCord took the picture in 1888 as he looked to the north. The Four Mile Creek was a subject often photographed by McCord, and based on the captions he used in his albums, he apparently preferred to call it the Tallawanda. The covered bridge at the top

left is the Black Bridge or Pugh's Mill Bridge. The iron bridge at the right is the Bonham Road Bridge that was later replaced. Today the flat land in the foreground is the Ruder Nature Preserve, part of the Three Valley Conservation Trust, and the land in the upper left is one of Miami University's athletic fields.

This mill stood near the intersection of Morning Sun Road and Somerville Road north of Oxford. Built by Frank Austin in the mid-1800s, it was a gristmill that operated in connection with a sawmill. Subsequently known by the name of a later owner, Pugh's Mill remained in business until the millrace was washed out in the Flood of 1913. The building was razed three years later.

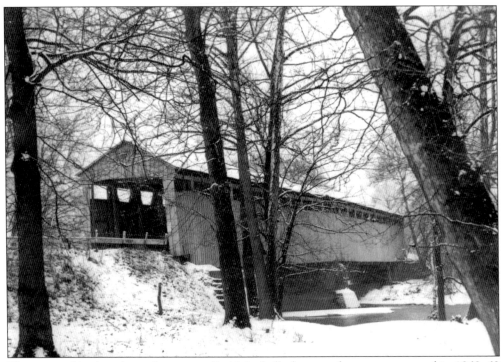

This covered bridge, shown here in an Earl Mitchell photograph, was constructed in 1868–69 and is the only one in Butler County that remains on its original site. It was built to span the Four Mile Creek north of Oxford on the old road to Morning Sun. Known as the Pugh's Mill Bridge and as the Black Bridge, it was by-passed by a new road in 1953.

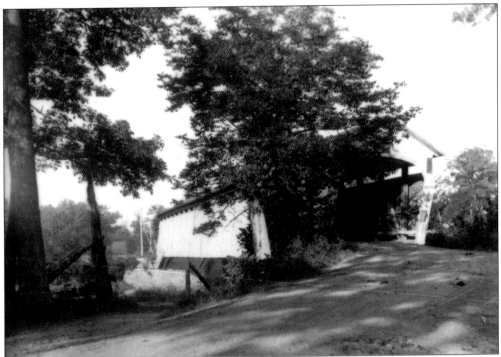

A covered bridge known as the White Bridge spanned the Four Mile Creek east of Oxford on what was then called the Darrtown Pike. Built in 1872, it was weakened a few years later when a floating tree lodged against it during a flood. Despite its condition, the bridge remained in use until 1912.

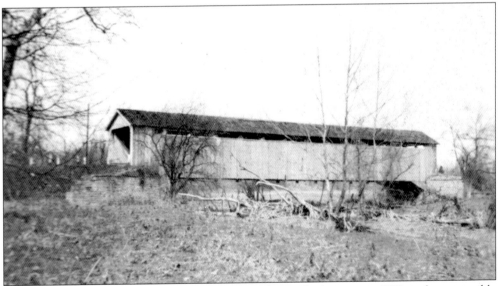

This covered bridge, which spanned Indian Creek, was built prior to 1873 and was possibly moved from another site. The bridge was located west of Oxford near the Indiana state line on Fairfield Road (named because it led to Fairfield, Indiana). The bridge was dismantled in 1966 and reconstructed in Governor Bebb Park in the southern part of the county. It is shown here in a 1949 photograph by Bryan Ketcham.

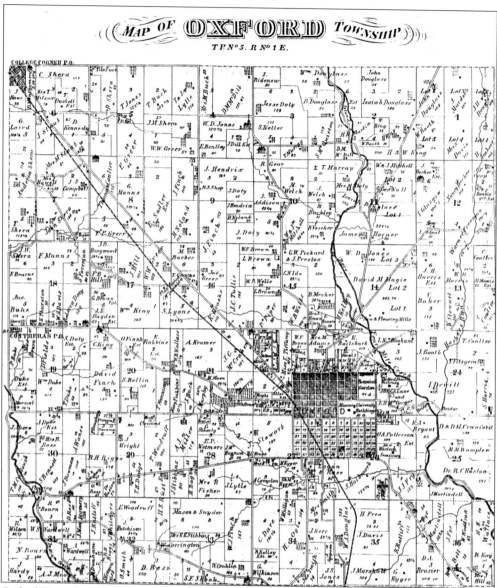

Oxford Township, located in the northwest corner of Butler County, is shown here as it appeared in L.H. Everts' *Combination Atlas Map of Butler County, Ohio*. Published in 1875, the map shows the Village of Oxford in the southeast quadrant, still one mile square. College Corner, named because it was in the corner of the college township, can be seen at the upper left. The railroad track runs diagonally across the township from College Corner to Oxford before turning south toward Hamilton. The Four Mile Creek enters Butler County from Preble County to the north and flows south, passing just east of the Village of Oxford. Indian Creek can be seen flowing across the southwest corner of the Township. In addition to showing roads, the map also indicates locations of schools, churches, cemeteries, bridges, mills, orchards, and houses.

114

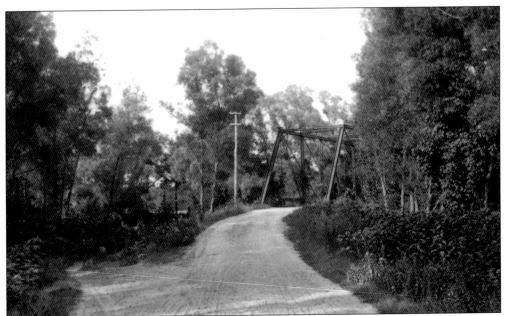

Occasionally called the Red Bridge, this span crossed the Four Mile Creek on Bonham Road northeast of Oxford. Constructed in 1880 by a Dayton, Ohio, company, it originally had oak flooring. When local photographer Frank R. Snyder produced this postcard in 1907, he titled it "Iron Bridge." It was replaced in 1965 by a bridge that could support heavier loads.

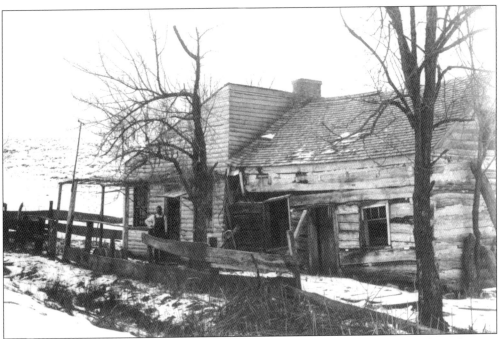

Photographer William McCord took this picture in the 1880s and identified it only as "Pioneer Cabin." The home was probably built in the early 1800s and was one of a number of rustic buildings that could still be seen in rural areas of the township well into the twentieth century. The man in the photograph was not identified.

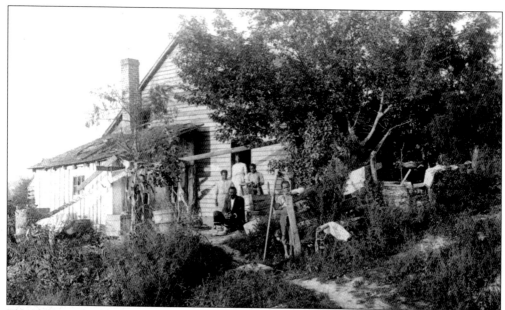

This African-American family lived somewhere in Oxford Township in the 1880s. William McCord identified his photograph as being "near Oxford" but did not record the names of the family members. At that time, African Americans made up close to 10 percent of the population of the Village of Oxford but a considerably smaller percentage of township residents.

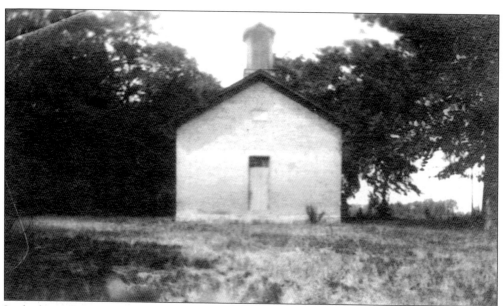

In the late 1800s and early 1900s, there were nine one-room schoolhouses in Oxford Township. This one in District No. 9 was known as the Reily Road School and is preserved today as a residence. All the schools acquired the name of a road, family, community, or geographic feature with which they were associated: Nation, Doty, Bethel, Salem, Beckett, Bonham, Oakland, and Girton. (The last was also called Indian Creek.)

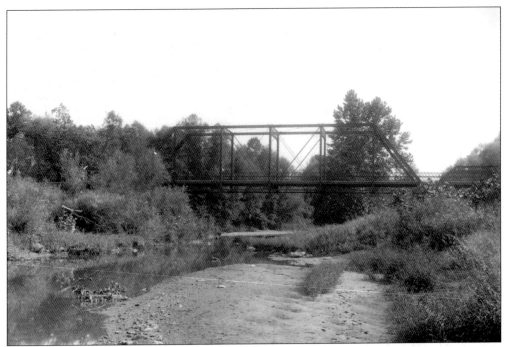

In 1913, a new bridge was built east of Oxford replacing an earlier covered bridge that spanned the Four Mile Creek on the Darrtown Pike. The metal bridge remained in use until the road was re-aligned and improved in later years. Photographer Frank R. Snyder titled his photo "Tallawanda Bridge."

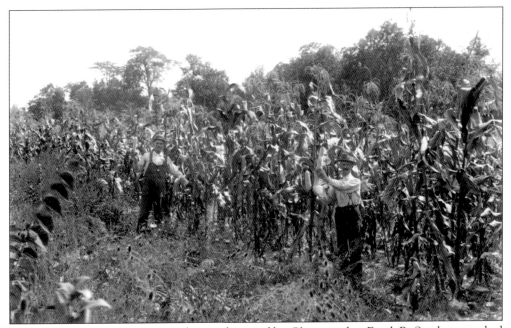

This 1914 corn crop was one worth recording on film. Photographer Frank R. Snyder was asked to take this picture on the Oxford Township farm of Thomas McDill when harvest time was approaching. Both the height of the stalks and the size of the ears were notable.

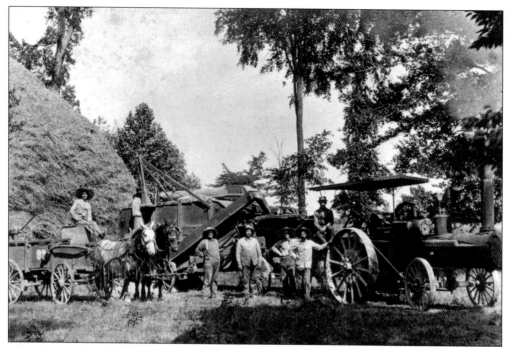

This threshing machine (at center) was powered by the Geiser Peerless steam traction engine (at right) and was used to separate grain from chaff. The height of the stack (at left) was one indication that the job was done and that it was time for the crew and equipment to go to the next farm. The photograph by Earl Mitchell was taken in the early years of the twentieth century.

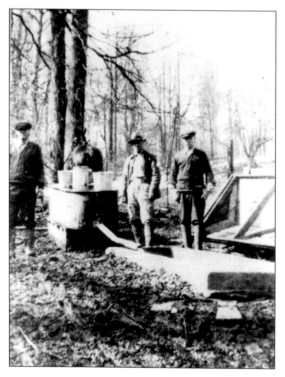

These men were photographed at a sugar camp north of Oxford in the 1920s. The process of tapping maple trees for sap and boiling down the sap to make maple syrup and maple sugar took place in late winter of each year. Property owners with enough maple trees and equipment could add substantially to their incomes by selling maple products.

Ten
NOTABLE RESIDENTS

William Holmes McGuffey, writer of the famous *McGuffey Readers*, was a professor at Miami University from 1826–36. During his years in Oxford, McGuffey compiled the first of the series of schoolbooks that would be the standard ones used by generations of American children. His home, a National Historic Landmark on the southeast corner of Spring and Oak Streets, is preserved as a museum.

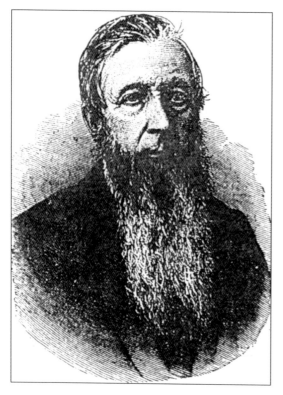

David M. Magie, one of the developers of the Poland China hog, moved to a farm in Oxford Township in 1847. He moved to the Village of Oxford in 1859 where he built his house at 15 North Beech Street. A statue of the Poland China hog stands near the Butler-Warren County line to commemorate the work of Magie and others who developed the now famous breed of hog.

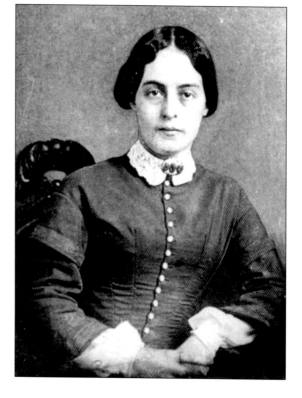

Caroline Lavinia Scott, who grew up to become the wife of U.S. President Benjamin Harrison, was born in Oxford in 1832. A graduate of the Oxford Female Institute, she served as the country's First Lady from 1889 until her death in the White House in 1892. The house in which she was born stood at 2 South Campus Avenue until it was razed in 1945.

Benjamin Harrison, an 1852 Miami University graduate, became the 23rd U.S. President. In 1853, he married Caroline Scott in her family's Oxford home, which stood at 131 West High Street until it was razed in 1940. Although Harrison lost his bid for a second term in 1892, he and the vice presidential nominee made history when theirs was the first national ticket to include running mates from the same university.

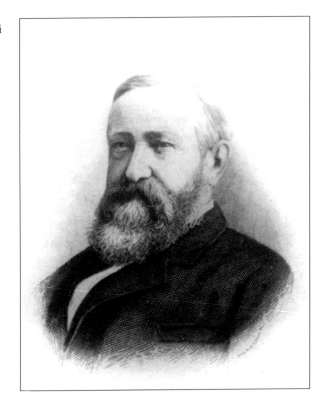

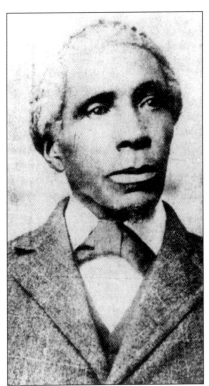

John S. Jones was born in Butler County in 1819 and in 1852 became the first African American to testify as a witness in a Butler County court. Jones moved to Oxford Township shortly after purchasing a farm on Booth Road in 1859. From this location south of town he operated a station on the Underground Railroad while his two sons served in the Union Army during the Civil War.

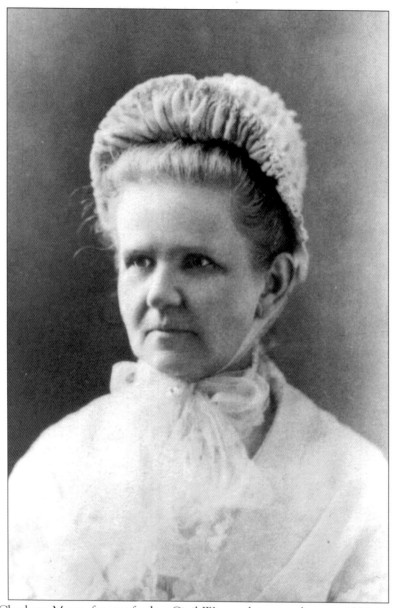

Cynthia Charlotte Moon, famous for her Civil War exploits, was born in 1829 in Albemarle County, Virginia. In 1834, her family moved to Oxford where the girl nicknamed Lottie grew to adulthood. She was engaged to a future Union general, Ambrose Burnside of nearby Liberty, Indiana, but on the day they were to be married, she left him standing at the altar. When she became engaged to attorney James Clark, he made sure that she did not treat him in the same manner. According to local lore, Clark quietly pulled a pistol from his pocket on their wedding day in 1849 and said, "There will either be a wedding here tonight or a funeral tomorrow." During the Civil War the Clarks lived near Jones' Station in southeastern Butler County and secretly worked to aid the Confederacy. Lottie, who traveled in disguise, carried dispatches through Union lines and met with southern sympathizers in Canada. In later years, the Clarks lived in New York where Lottie was a newspaper correspondent and a novelist. She died at her son's home in Philadelphia in 1895.

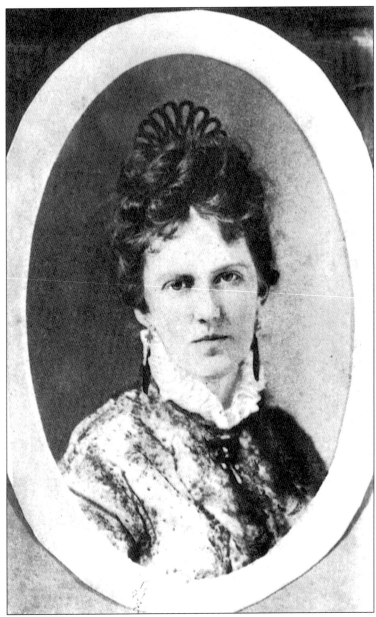

Virginia Bethel Moon served the Confederate cause during the Civil War by carrying dispatches and smuggling medical supplies. A younger sister of Lottie Moon, she was born in Oxford in 1844. Soon after the Civil War began, Ginnie, as she was nicknamed, left Oxford for Tennessee where she began her own efforts to aid the South. It was claimed that she was engaged to over a dozen Confederate soldiers at the same time. Her explanation was that if they died, they died happy, and if not, she did not care. On one occasion, she was arrested for carrying contraband goods—opium, morphine, and camphor. She was brought before Union General Ambrose Burnside, her sister's former suitor, but she was soon released on parole. After the War, she ran a boarding house in Memphis, played small roles in several Hollywood movies, and began writing her memoirs. She died alone in her New York apartment in 1925 and was buried in Memphis. The Moon family home in Oxford still stands at 220 East High Street.

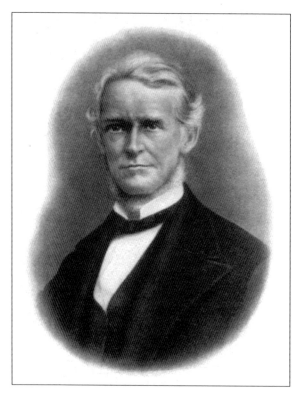

William Dennison, a Miami graduate of 1835, served as Ohio's governor from 1860 to 1864, presided over the Republican National Convention that re-nominated Lincoln, and later served as U.S. Postmaster General. Two other men who spent their college years in Oxford served as governors of Ohio, and four more became governors of Illinois, Indiana, Iowa, and Missouri. Another was governor of the Idaho Territory and then of the Arizona Territory.

David Swing, who became a popular nineteenth-century preacher, graduated from Miami University in 1852 and returned to Oxford after attending a Cincinnati seminary. Later he was the minister of a Chicago Presbyterian Church until his liberal views forced him out. Swing's followers then organized an independent, non-sectarian church where he preached to thousands of people. His appealing sermons were published in leading newspapers, bringing him national recognition.

Whitelaw Reid, journalist and diplomat, spent his college years in Oxford, graduating from Miami in 1856. His newspaper career took him from the *Cincinnati Gazette* to the *New York Tribune*. He also served as minister to France before running for U.S. vice president in 1892. After his defeat, Reid continued as editor of the *Tribune* until asked to serve as ambassador to Great Britain. He died in London in 1912.

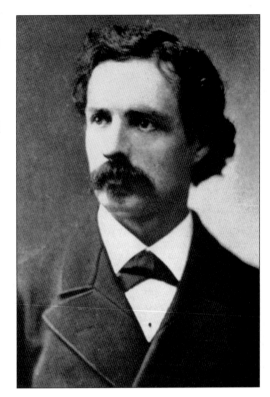

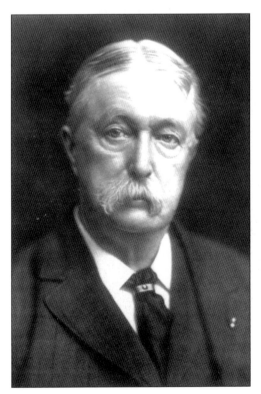

Considered the "Father of the U.S. Public Health Service," John Shaw Billings graduated from Miami in 1857. After medical school and service as an army surgeon during the Civil War, he headed the medical library of the U.S. Surgeon General's office. There he co-wrote *Index Medicus*, the leading guide to medical literature. His views influenced hospital design nationwide, and his portrait was installed in the National Library of Medicine.

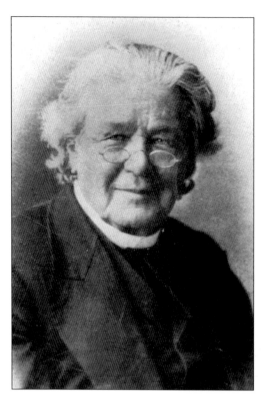

Lorenzo Lorraine Langstroth, known as the "Father of Modern Beekeeping," lived in Oxford from 1858 until 1887. A noted apiarist, he wrote the leading book on beekeeping in 1853 and was the inventor of the moveable-comb hive, a development that revolutionized honey production throughout the world. His home still stands at 303 Patterson Avenue and is a National Historic Landmark.

Oliver Toussaint Jackson, the founder of Dearfield, Colorado, was born in Oxford in 1862. Influenced by the writings of Booker T. Washington, Jackson established an African-American agricultural community in Weld County, Colorado, in1910. In the 1920s Dearfield prospered with over 700 residents, but the economic depression and dust storms of the 1930s forced settlers to abandon their "dear fields." Within another decade, only a ghost town remained.

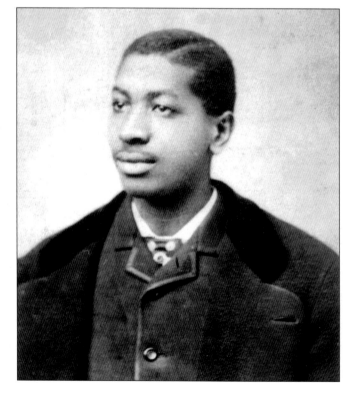

Known as the "Dean of American Composers," Edgar Stillman Kelley lived in Oxford from 1910 until 1934. He was already a well-known figure when he accepted the invitation that made him the country's first artist-in-residence on a college campus. He and his wife came to Western College for Women, and it was here that he composed some of his best work. Their studio home remains on the campus.

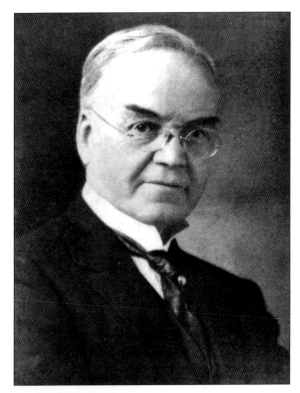

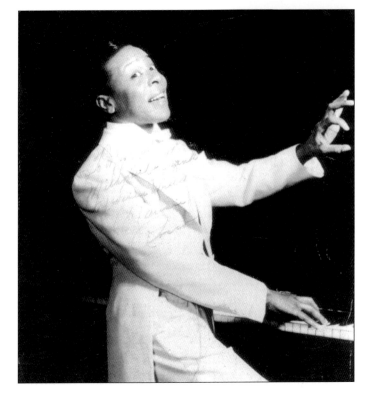

Born in Oxford in 1915, Maurice Rockhold became famous as the jazz musician who played the piano while standing up. Using the stage name, Maurice Rocco, he performed in several Hollywood movies in the 1930s and 1940s and then pursued a career that took him around the world. He was murdered in Bangkok, Thailand, in 1976 and is buried in Woodside Cemetery.

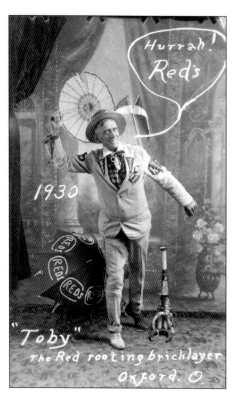

Harry Thobe was Miami's most flamboyant sports fan; he boasted of having attended 54 consecutive Homecoming football games. Also a supporter of the Cincinnati Reds baseball team, Thobe bragged about going to 20 World Series games without paying admission. He also claimed to have gate crashed one Sun Bowl, three Orange Bowl, and eight Rose Bowl games. For over half a century thousands of spectators witnessed his sideline antics.

Miami alumnus Earl Blaik coached Army football at West Point. He was one of a number who graduated from or coached at Miami on the way to a notable career leading college or professional sports teams. Others were Weeb Ewbank, Paul Brown, Paul Dietzel, Ara Parseghian, Bo Schembechler, John Pont, and Woody Hayes. Because so many winning coaches came from one university, Miami became known as the "Cradle of Coaches."